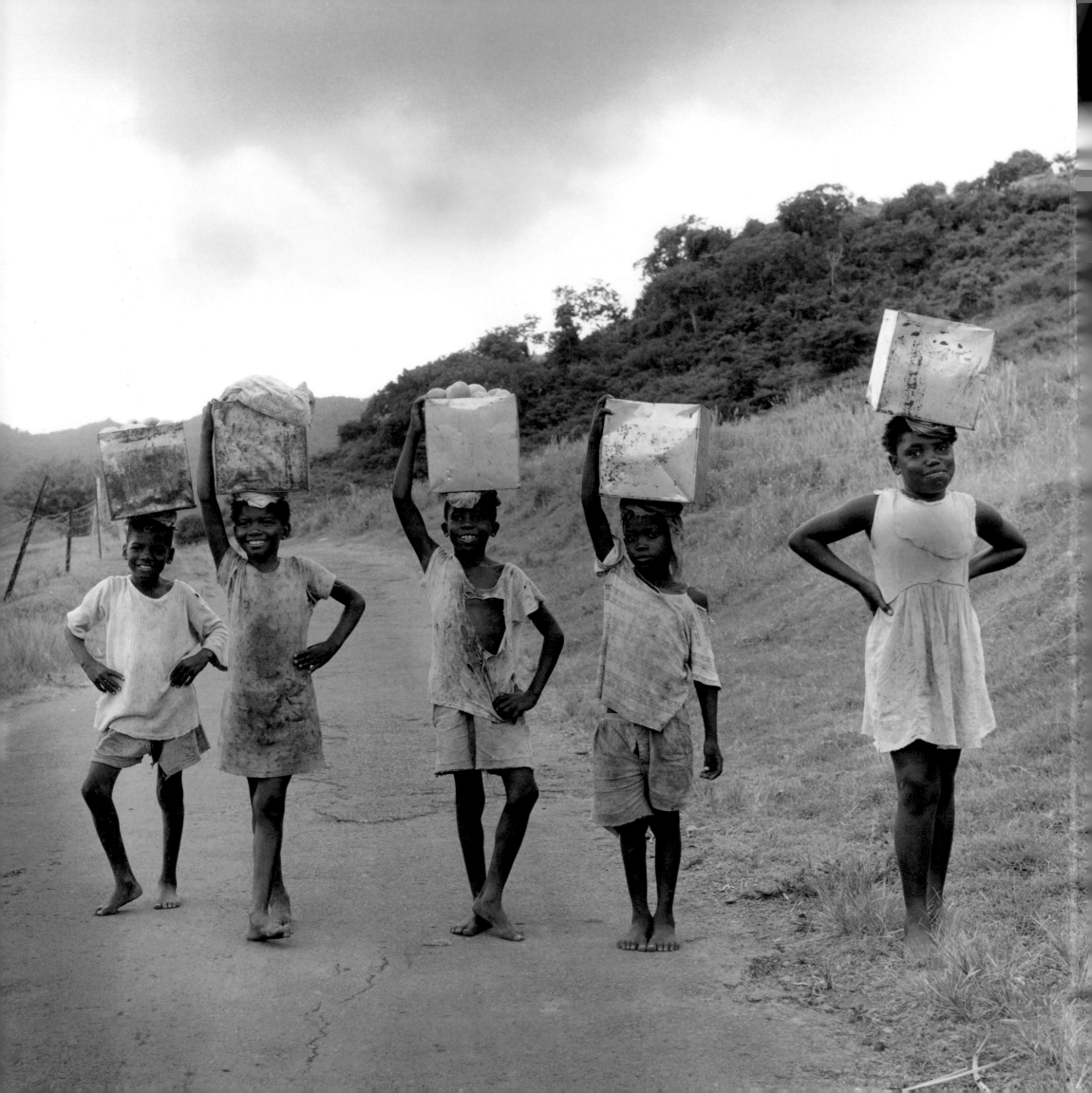

UNDER ONE SKY

MARGO DAVIS

Foreword by Margaretta Mitchell

To Tracy
With birthday wishes
from one who works
with images to one who
works with words. And
we are both Bennington alums.
Margo Davis
Sept 28, 2004

Stanford University Press
Stanford, California 2004

Stanford University Press

Stanford, California

© 2004 by the Board of Trustees of the

Leland Stanford Junior University.

All rights reserved.

Printed in the United States of America on acid-free,
archival-quality paper

Library of Congress Cataloging-in-Publication Data

Davis, Margo Baumgarten.

Under one sky / Margo Davis ;

foreword by Margaretta Mitchell.

p. cm.

ISBN 0-8047-4266-9 (cloth)

1. Portrait photography. 2. Documentary photography.

3. Davis, Margo Baumgarten. I. Title.

TR680.D295 2004

779'.2'092—dc22 2004009999

Original Printing 2004

Last figure below indicates year of this printing:

13 12 11 10 09 08 07 06 05 04

CONTENTS

For Margo Davis, *Under One Sky* is the culmination of over three decades of photography. With a compassionate eye, Davis has selected faces from a wide variety of ethnic groups as a way for her photographs to speak, to express hope for the future of humankind. Within the covers of this book she has gathered ordinary people, honored their dignity as individuals, and created a collective portrait of a global human family. This series of portraits, with a few exceptions, bears witness to the lives of rural and village people from each continent of the world. If each portrait serves as a messenger, tracing one life story from one culture, then together these particular plain folk become one story. Portrayed side by side they form a chain of individuals who represent the survival of a civilized humanity. Together, their faces symbolize universal human life, woven here in the one language all the world can read: photography.

When Davis makes a portrait it is an act of compassion, connecting her with the core of humanity within an individual. The specific person is what matters. Mutual trust is essential. For her, the result must always be an intimate portrait. "I am drawn by the spirit of the person, the sparkle in the eyes. What I see is a reflection of the soul." She waits until she gains acceptance from the subject and then finds a comfortable place free from intrusions to make her photograph. The setting might be a timeless backdrop of stone or wood, rather than a specific space. For Davis, finding these faces is a visual and personal quest. The person she chooses could be a friend or a stranger, but the respect for the individual is always palpable. In many instances, Davis explains, "I do not know who they are at all. It is the encounter of two human beings. I just happen to have a camera in my hand and the desire to communicate in pictures."

Davis joins the ranks of photographers who have traveled the world to bring peoples of many cultures together on the pages of a book. She must seek a patch of reflected light, making a corner of the street a calm place without the aid of a tent studio à la Irving Penn, for example. While appreciating the mastery of Penn's elegant portraits, Davis finds in August Sander a more kindred mentor for understanding the concept of making portraits to create a world. Though Sander's work is limited to the German people of the Weimar Republic, Davis shares with him an affinity of approach and type. Their subjects come mostly from the photographer's country; the style is direct, honest, and uncontrived. The sense is simply the subjects' presence. Davis's pictures, "Schoolboy Riding Goat, Norway" (Plate 3) and "Xenia, San Francisco, CA, USA" (Plate 5), mirror that quality in their unaffected presentation and their subjects' spontaneous expressions. This economy of means can be claimed as the hallmark of a Davis portrait.

The lifework of Margo Davis fits squarely into the contemporary chapter of documentary photography. Even before she picked up a camera, she

FOREWORD *by Margaretta K. Mitchell*

was attracted to photography. As a young student living in Paris in 1963, she yearned to create her emotional response to that romantic city in concrete form. A remarkable photographic exhibition by Eugene Atget showed her a way. With a $50 Zeiss Ikon camera, she set out to memorialize her Paris. Introduced to darkroom techniques she plunged into the world of black-and-white photography, which remains her central means of creative expression.

Documentary photography is fundamental to twentieth-century modernism. Dedicated practitioners are often motivated to focus on particular cultures before those societies lose their identity in the blur of modern civilization. The process becomes a race against time to capture, fix, and preserve images of the changing human and physical landscape. Style is not an end, but rather a means. The love of reality, whether romanticized or not, precedes any fashionable concept of beauty. In fact, ideally the photographer becomes the medium through which the subject lives in our collective memory.

These nomadic photographers become witnesses for their subjects. Their images tell stories. Their techniques and materials do not detract; rather, they are made to serve that higher calling. This is not to say that the artistic quest for the perfect print is unimportant or that subjective expressiveness is not bound up inherently in the telling of a visual story. Both are crucial to the work of the best documentary photographers.

As a young photographer Davis was fortunate in finding guidance. Under the direction of landscape photographer Dave Bohn she mastered the craft. "Dave also made sure that I understood the difference between commercial and personal work, always encouraging the self-imposed assignment over everything." When she moved to San Francisco, Davis found another influential teacher in Ruth Bernhard, for whom she worked in exchange for the use of her darkroom and the opportunity to observe at close range the life of a truly inspiring woman photographer. Davis remembers Ruth arranging a still life in her studio: "It was the standard I set for myself in the field—simplicity, harmony, proportion, clarity and love." She also studied informally with one of the greats, Minor White, in Arlington, Massachusetts. "In Minor's house we would meditate on images. He trained us from the start to give time and space and quiet to the process of understanding the meaning in photographs. He taught me to believe in magic."

Among twentieth-century documentary photographers of human cultures Paul Strand enjoys the reputation as the most respected. Having been present in Alfred Stieglitz's historically significant Camerawork early in the century, he continued for several generations to be considered the icon of modernism in American photography, particularly for his portraits. Davis looked to Strand's example as she deepened her commitment to photography. She was affected by the consistency of his lifetime achievement, noting

the simplicity of his compositions, the human dignity of his subjects, the quiet heroism of the ordinary person, the way he seamlessly used elements of the environment to complete the visual biography of the subject. Strand's portraits exemplify the idea that the universal can be found through an intense scrutiny of the particular. Most of all, Davis resonated with the way in which Strand, the artist, disappeared into the portrait, letting the subject occupy center stage. This is the tradition of straight photography, one that Davis herself has consistently claimed as the major influence on her work.

The visual direction of Davis's lifework began in the summer of 1967 in Antigua, where she traveled to meet her future first husband's family for the first time. The West Indies' island culture instantly attracted her, and she responded aesthetically as well as personally with her camera. Her life and her subject matter merged into a series of highly personal and expressive photographs taken during subsequent summer pilgrimages to visit family on the island. These became her first book, *Antigua Black*, created in collaboration with her first husband and published by Scrimshaw Press in 1973.

Davis set a high standard with this body of work. In the portrait of "The Reverend George A. Weston, Antigua, West Indies" (Plate 60), the subject sits back comfortably in the chair, legs crossed, head turned toward us. With a wise and patrician grace his steady gaze is patient and kind. One imagines a deep history hidden in the landscape of facial lines that represent a life lived for others. Who is this all-knowing shaman, intently listening, who sits, priestlike, inviting us to speak as he keeps secrets in the shadows? The layered meanings and the calm of the scene, with the light coming from the shuttered window on the left, echoes the paintings of Vermeer. Light, of course, is the "paint" of the photographic medium, often the means of creating the style of a picture. Here in this early image, Davis masters the shaping of form and content with natural light.

While the Antigua photographs stemmed from Davis's personal connection to the culture, the next project, photographed in Nigeria, resulted from her deliberate search for the roots of Antigua's people in Africa. Davis spent several years visiting the Fulani, a tribe of nomadic herders whose living depends on the milk and meat of their cattle. Her travels there encompassed research assignments for the International Livestock Center for Africa (ILCA). In addition to photographing their customs and environment, Davis recorded the work of the herders, and especially of their wives, whose activities included handling the calabash, a carved gourd essential to milk production. In the process of working in West Africa, Davis embraced the canon of documentary photography and established her spare portrait style.

Davis may perhaps appear to be a romantic because of her evident idealism about the purpose of her pictures of different ethnic peoples. Her ap-

proach at this point in her career resembled that of an anthropologist, living with the tribe and striving toward an honest understanding of the people and their customs. The photographs from this period convey immediacy, a true feeling for the people and their lives. People present themselves before her camera in their natural postures of daily life. It was during her visits to the Fulani that Davis discovered that her interest was turning more in the direction of pure portraiture than in the photojournalistic study of customs. Her work began emphasizing the encounter more than the context. For example, "Habu, Fulani Herdsman, Nigeria" (Plate 56) shapes our feelings for the whole tribe. Davis brings us up close but with such sensitivity for the subject's faltering eyesight that his dignity remains uncompromised. We see pride in his posture. The labor of centuries shows in his stance and in his relationship to space: the hut behind him accentuates his solitude and ties him to the earth. "If you think of photography books on Africa," Davis reminds us, "they mainly focus on the most exotic and colorful rituals in order to produce a sensational view. They reinforce a stereotype of African peoples that I see as a kind of racism."

Davis's Antigua and Nigeria projects draw on her expressed affinity for the work of the photographers of the Farm Security Administration of the 1930s, in particular Dorothea Lange, best known for her affecting images of migrant farmworkers. In much the same way that Lange identified with American countrywomen, Davis feels comparative kinship with rural peasant women around the globe. She recalls with fondness the moment in 1968 when Paul Taylor, Lange's widowed husband, specially approached her at a San Francisco Women Artists' group exhibition at Focus Gallery that included Davis's Antigua photographs. He told her that he had never seen any work that was so reminiscent of Dorothea's approach. Davis laughs recounting a more caustic comment from Imogen Cunningham, whose photography she much admired. In a slightly curt manner and with sharklike wit, Cunningham declared that she didn't know why some photographers didn't photograph in their own backyards! "Of course, Antigua had become another of my backyards."

In more recent years, Davis has reflected on the seminal influence Lange has had on her work. "Lange was more interested in the social, external statement about people's circumstances than I am. My interest is in the interior, psychological portrait. That is what I mean when I say today that I am not strictly a documentarian. After the Africa work I grew out of a desire to photograph the surroundings of people's lives." Recently, when Davis made a portrait of her elderly neighbor, "Rose Feiner, Palo Alto, CA, USA" (Plate 59) she chose to crop in as close as possible, allowing the face to become a landscape of her subject's life, the inquiring eyes to speak of her undiminished intelligence.

Though Davis is steeped in this humanist vision of the portrait as a social document with its underlying mission of social awareness, she moved away from the documentary style. Keeping her compassionate eye, she has abandoned the details of the social context as much as possible. She seeks to portray interior psychological truth through simplicity of expression, gesture, and composition. "Monk, Angkor Wat, Cambodia" (Plate 54) is a fine example of this new focus. Seated on the stone steps of a temple, the monk meditates deeply, eyes fixed in a stare, brows furrowed, body held in an alert but relaxed position. Diffused light falls on his shaved head and along the ridge of his nose, leaving his face in gentle shadow and allowing the folds of his garment to envelop him in swirls and streams of graded tones. We see him square on from the front, the way we might experience a statue of Buddha himself, gazing serenely, indifferent to the camera, yet somehow aware of it. Without any exterior directional light to create a space, we are invited to imagine a sacred inner light.

Occasionally, Davis selects some of the surrounding environment to include as background, as in the "Romanian Gypsy, Rendek Farm, Kerekegyhaza, Hungary" (Plate 22). Here the porch provides a perfect frame for the figure and allows filtered sunlight to plant a road map of shadows across his clothing, and bounce up to animate his eyes. More often, Davis moves in closer in her desire for connection, as in the face of "Doña Margarita, Teotitlan del Valle, Mexico" (Plate 29), where the patch of light illuminates her brow as if in blessing. Not a posed, but rather a composed portrait. No special luminosity. Only daylight. No technical tricks. No wide-angle lens to lend a baroque rhythm to the composition. Instead, her close-up framing of the face creates an iconic image of subtle symmetry that is exquisitely personal.

In some sense, these photographs bear an overlay of nostalgia in the very fact that the photographer is seeking solace as much as connection to those peoples who are identified as rural, close to the earth. As a portraitist, Davis takes comfort in the rural setting because she wants to use the place where people feel most at ease with themselves. And where she herself feels most comfortable. For the photograph "Doña Juanita and Children, Teotitlan del Valle, Mexico" (Plate 43), Davis found the sweet northern light that causes a subtle transition of light and shadow in the subject. The mother, encircled by the arms of her older daughter, embraces the younger one with a particularly protective gesture, drawing her in close. The child fits into the curve of her mother's side with a natural grace. The eyes of the older child claim a proud love for her mother, whose face reveals a more protective expression, while the youngest looks wondering and curious. The three figures form a perfect triangle, bringing to mind the domestic mothers and children painted by Mary Cassatt, and,

earlier, the classic iconography of Madonna and child in Italian Renaissance painting.

The unaffected, natural quality of this portrait fits into the larger scheme of the whole book. The portraits begin with an image of "Abashe and Grandchild, Abet, Nigeria" (Plate 1) and progress through pictures of children and couples, individual men and women, and ending with the old. Some of the pairs demand comparison. For example: the weathered faces of both the seated "Zapotecan Couple with Bag, Oaxaca, Mexico"(Plate 53) and "Hussein and Aisha, Berbers, Morocco" (Plate 52) both tell the story of age and culture. The harsh daylight and the angle of the composition accentuate the stiffness and apprehension of the Moroccan couple, whose posture unites them into one form like an ancient Egyptian sculpture. In contrast, the open shade on the stone step allows a glimpse into the faces of the Mexican couple, whose expressions engage us with a liveliness captured in many kinds of folk art figures.

In image after image Davis shows a singular fondness for expressing strength as a component of beauty in her women subjects. "Beatrice, Cachoeira, Bahia, Brazil" (Plate 17) is as elegant, quiet, and contained as an Italian Renaissance marble bust by Francesco Laurana. The subject of "Mbere Woman, Kenya" (Plate 37) braces a huge block of stone against her shoulder. Her head takes on a silhouetted rocklike shape as imposing as the stone is heavy. Sometimes, gesture tells all. In "Lami, Abet, Nigeria" (Plate 44) the young woman stands leaning her shoulder against the wall, her left foot flexed in a simple gesture of confidence that is balanced by the casual crossing of arms. Davis deftly captures her subject's youthful poise through these details.

Hands also talk, animating many of these portraits. In "Women with Henna Hands, Marrakesh Souk, Morocco" (Plate 26), we find ourselves in the middle of a conversation between one woman, whose gesture directs our eyes to rest on the woman facing us, her henna hand on her cheek, her eyes softly amused by our curiosity. The darker tones of the figures create intimacy, a paradoxical privacy that opens to us but simultaneously withholds a mystery for us to ponder.

We know how much a portrait can be loved, especially by those who care deeply for the subject. The artistic challenge of a portrait is often invisible, magical, spoken of as a product of intuition more than talent. Often the story of the portrait's making becomes more fascinating than the portrait itself. Deep down we know how difficult it is to achieve a great image of a person because personality is mysterious, mutable, and often layered in such a way that the truth of a person is buried under piles of persona. And then there is time. Personality fluctuates with changing moods and the seasons and rhythms of life.

Moreover, every portrait expresses more than a single image of a person. It becomes the sum of many personalities, beginning with the sitter's own particular character, caught in the interaction with the photographer. Here we speak of a balance of two: the observer and the observed. However, in every portrait a third person—the viewer—enters, producing a dangerous equation: the triangle. The three points represent not a balanced pair but a triad of subject, artist, and viewer. In fact, the viewer becomes part of the life process of a portrait. An image lives beyond the life of the person, beyond its original purpose, transformed by time into more than a record of a certain person at a specific time.

Historically, portraits stand as one of the main expressions of culture. Portraiture is central to the history of photography itself. During the nineteenth century, the burgeoning middle class inherited the elite tradition of portraiture from painting. Photographic portrait studios flourished. By the 1850s every American who could afford a twenty-five-cent picture could sit for a daguerreotype portrait. Today, the snapshot rules. Everyone can and does photograph each other, and it has become increasingly difficult to understand how to place value on the skill of the portrait photographer. A great portrait captures more than a likeness, burrows to the essence of a person. Somehow it transcends technique, but we fall into the habit of discussing the lighting, the "pose," a lively expression, an exotic costume, and the social context of the person. Reading a face is as important as reading a light meter. The skills of psychological preparation and experience cannot be transmitted as a set of technical procedures.

Over time, a serious photographer of people develops a sixth sense in approaching a subject, often intuiting depth of personality without previous acquaintanceship. To illustrate, we find in the pairing of "Ingrid, Torpo, Norway" (Plate 57) with "Mr. Bun, Monk, Shirakawa-go, Japan" (Plate 58) both a contrast in cultures and a common sacred space. The ancient wood of a Japanese village house frames Mr. Bun's dark robe, emphasizing his hands, which are placed in his lap, forming a meditation mudra. Even with all the subtle differences, Ingrid's pose reflects his. Both are bathed in the light of late day, which emphasized their faces and hands, allowing them to emerge from the background in a manner reminiscent of a Rembrandt painting.

By placing portraits such as these from different cultures opposite one another, Davis's message of a global village reminds us of the celebrated 1955 exhibition *The Family of Man.* This mammoth project, created by Edward Steichen at the Museum of Modern Art in New York, projected a vision of the "essential oneness of mankind throughout the world." It also reflected the increasingly pervasive presence of photography in modern life, both its value as art and its inherent artlessness. This exhibition and the resulting book

traveled all around the world for years, capturing the imagination of several generations of younger photographers, Margo Davis among them.

The portraits of Diane Arbus project a darker vision of the human family, possibly the antithesis of the ideals found in *The Family of Man*. She was fascinated by the eccentric and surreal in the human species. A marginalized edge of society became her turf and took over her life. Arbus believed, as Davis does, that "the objective nature of photography could not be disentangled from the experience of the personal encounter" (*Diane Arbus: Revelations*, p. 62). In this way, Arbus and Davis are very much alike in their approaches, even though their intent and styles are so different. The encounter is personal, observant, and subtle, as if two pilgrims have met at the side of the road, each coming from a different place, and have stopped to acknowledge each other and, in the wheel of life, move on. So the portrait is not only a physical artifact. It represents a moment of magic, captures an entanglement of memory, holds the feelings of one conscious being for another. It is a crying out in sorrow or in joy that says We Lived and we were acknowledged by someone who cared enough to record an image of us.

Both Arbus and Davis are interested in "other." Davis explores the "other" of ethnicity. She has worked to unravel the history of slavery in her search for those who inherited that legacy in Antigua, Nigeria, and, later, Brazil. She came to see people everywhere as part of one great extended family. As Davis says, "the people are the royalty of our earth." In "Blind Woman, Oaxaca Cathedral, Mexico" (Plate 30), she found in the afternoon light "a glow that seemed like a light from the heavens." Because she was not able to ask permission directly from this blind beggar, she hesitated to approach her. Then she saw an ethereal light dappled on the surface of both stone and flesh. Her desire to portray this woman as symbolic "royalty" overcame her fear of clicking the shutter. In that moment of deep silence she felt the power of the human spirit emanating from this humble soul.

These portraits stand out against the cacophony of today's postmodern aesthetic. Contemporary photographers commonly get caught in the spectacle of the exotic, becoming voyeurs of the sensational or erotic, or they push the world away with alienating, cool, edgy images. Margo Davis's photographs purposely avoid the sensational and decry the exotic. As Francis Bacon said in a remark from 1620 that Davis keeps as her credo, "The contemplation of things as they are, without terror, or confusion, without substitution or imposture is, in itself, a nobler thing than a whole harvest of invention." Dorothea Lange had this quotation pinned up on her darkroom door. When she was thirty-two, Davis wrote this quotation on the first page of her journal (March 1976).

Margo Davis seeks the mundane for itself: the unheralded plainsong that speaks for all of us. In *Under One Sky* she bears witness to a kind of humanity that can be considered sacred on the earth.

UNDER ONE SKY

As artists we are drawn to projects that help us understand truths about ourselves. When we are young, we are so lost in the process that we make choices that seem random. Later, as Dante says, "nel mezzo del camin di nostra vita," in the middle of the road of our life, we gradually achieve some clarity, like the welcome clearing after a winter storm. The reasons for our choices make more sense and the thrust of our journey starts to take on more meaning.

That has certainly been true of my career as a photographer. I grew up in the 1940s and 1950s in the predominantly WASP community of Rowayton, Connecticut (Darien was the closest main stop on the train from Manhattan), as the first child of a Jewish family from New York City. We blended in quite well in Rowayton, yet, in some core place for which there are no words, not completely. In the subtle tension between warm feelings of acceptance and fear of rejection, a fog too mysterious for a child's comprehension, the direction of my life's journey took shape. Whatever dynamic this tension created, it propelled me toward a search into cultures other than my own, although for some part of the journey I was not aware exactly what this quest was about. Perhaps it was all about the "other" and its connection to me.

My interest in art began when I was young, a confluence of several factors: a mother whose ambition was to paint and who helped found the local art center; a lawyer father, many of whose clients were artists compensating him with artwork in lieu of cash; The Thomas School, which emphasized the arts and art history—all in a tiny community that included more than one art gallery and many New York artists. I was, in short, surrounded.

Much as I loved art, I realized in a ninth-grade drawing class that I had better find another means of self-expression. I studied ballet as a youngster, and then later drama, literature, and ceramics at Bennington College in Vermont. None of those were it for me. It was not until my junior year abroad at the Sorbonne in Paris, that, overwhelmed by the beauty of the city around me, I purchased my first camera. It was a $50, 35mm range-finder Zeiss Ikon bought for me in Germany by a friend who had returned home to Hamburg for her Christmas holiday. I took to the streets of Paris, abandoning the stuffy lecture halls of the Sorbonne and its sleep-inducing seminars about Molière, Corneille, and Voltaire, and began to play with the camera.

Paris, the City of Light, became my first photographer's inspiration. I still have the rough first prints, attempts at portraits of a friend, Daniel; my buddy Olga; a fellow student from Mozambique; and, of course, the de rigueur self-portrait by the River Seine. I made still-life images in my hotel room and photographed stone courtyards and shadows of trees

"The endless fascination of these people for me lies in what I call their inward power. It is part of the elusive secret that hides in everyone, and it has been my life's work to try to capture it on film."

—*Yousuf Karsh*

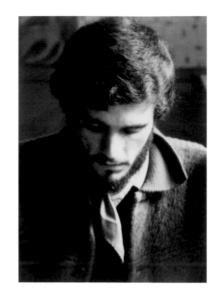

Daniel, Paris, France, 1966

along the embankments of the Seine. Most of these were nothing more than clichéd sketches, the kinds of doodles a novice scribbles in a cafe on the Boul Miche. I met many foreign students at the Beaux Arts in Paris, among them a Catalan sculpture student, Jordi, from Barcelona. It was he who taught me how to develop and print photographs in his studio where he had set up an old enlarger. With his help, I learned to develop negatives and enlarge small prints—*agrandissements*, as the French call them. That was it. From then on, photography was a passion.

When I returned home to Connecticut that summer, I set up a darkroom in my family's basement. The images appeared in fits and starts: my sister, Laurie, posed against the jagged rocks at Rocky Point and the silhouettes of a wooden pier at low tide on Rowayton's Five Mile River. It didn't matter the subject. I needed to be photographing. Many writers have remarked that writing is not something that they choose to do; it is something that they have to do. Photography was, similarly, something that I had to do, once I discovered it and began to be able to express myself creatively through the lens.

Unconscious searches being what they are, I next decided that Bennington College in rural Vermont was no longer the right place for me. In 1965, I went to California. UC Berkeley is where I spent my senior year of college. In the first fall months, I was spending all my spare time in the ASUC Studio darkroom. I traded in the 35mm Zeiss for a used twin-lens Rolleiflex. I loved the larger square negative and the opportunity for sharpness and detail that the new format afforded me.

Although I never abandoned my academic studies altogether, even finishing my degree in French literature, my entire reason for existence had shifted toward photography. It was at that point in time that Dave Bohn, who directed the Studio, became my mentor and guide. Dave would look at my contact sheets and stay very silent—kind of scary for a young beginner. At long last he would say things like, "You have two masterpieces in there. Go home and find them." This challenge—first, to identify those images and then to print them well—was what hooked me on the whole process.

The photographic process is much more than just a frozen-in-time moment in the field, although that is certainly the beginning. That moment is creatively shaped by interpretation and translation during the editing process. The magic of that moment must be captured and enhanced in the darkroom—in the image itself. Illuminating the emotion of an encounter with a subject is what inspires me, both in the field and in the

darkroom later. It is mysterious and elusive. Sometimes, the image the developer reveals is different than what my memory recalls. This image is a piece of paper coated with chemicals, but the magic is that this interpretation is now a new reality fixed on photographic paper, fixed for me and the viewer figuratively and literally. The elusiveness is this: the new reality can be an illusion too.

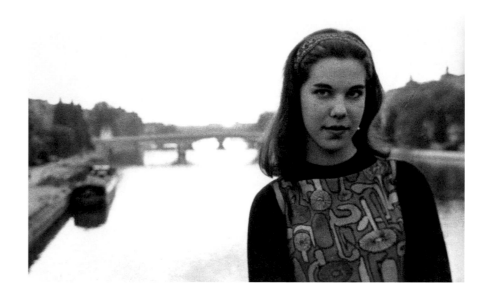

Self-portrait by the Seine, Paris, France, 1966

The ASUC Studio had a darkroom, potter's wheels, and an etching press. It was a cozy, safe community of artists, and we all exchanged our art, pots for photographs, etchings for pots, thereby giving support to each other's process. The world outside of the darkroom was chaotic in those days. Every time I looked out the window from the darkroom door, the Berkeley police were chasing students on campus. The famous Berkeley Free Speech Movement was in full swing. Both the free speech and civil rights movements of the 1960s affected our lives in all ways. I photographed at antiwar rallies and demonstrations all over the Bay Area. At the Greek Theater in Berkeley, I photographed a unique gathering of students and others advocating Black Power. However, I was never satisfied with these photojournalistic images. Simply recording current events on film was too literal a process for me.

In 1968, I married Gregson Davis, a Berkeley PhD from Antigua, in the West Indies. We moved to San Francisco and both commuted to work (he took the train south to teach at Stanford University, and I drove north to Sausalito, where I was an assistant to the photographer on a teacher's education project). We lived in the lower apartment of Lawrence Ferlinghetti's old Victorian red house on Potrero Hill and spent our summers in Antigua, where I started photographing in the villages.

I now faced the challenge of finding a new darkroom in San Francisco. Tom Baird, a fellow photographer, introduced me to Ruth Bernhard, a pivotal individual in my life, although I didn't realize this meeting's full impact until later. Ruth gave me the opportunity to use her darkroom in exchange for assistance in planning her workshops.

And what an opportunity that was. Ruth was working a few feet away, in her living room-studio while I was printing my Antigua photographs in the darkroom adjacent to the kitchen. She taught me to burn and dodge as only a brilliant master printer can. She showed me shadow detail on the negative that I had never made visible on the print. In one Antigua portrait (Plate 21), Ruth pointed out that on the negative there was significant detail in the woman's hair above her bandana. On the print that was still dripping with hypo fix, the hair had blocked up entirely.

3

However, way beyond the technical and so much more important than the skill of making prints, Ruth offered me a vision of balance and of light and shade in a black-and-white image—whether in a shell or in a nude or in the landscape of a face. She shared the wonder of it all.

I continued to photograph in the summers in Antigua; at home in my Potrero Hill, San Francisco neighborhood; and in Palo Alto, where we moved in 1973. *Antigua Black* was published that year, a collection of photographs with text about the island and its people. I began to teach photography at UC Berkeley and Santa Cruz Extension programs as well as at Stanford and other institutions in the Bay Area. By teaching photography for travel programs in Europe, I was able to fund and continue my personal work. As I traveled to different countries, I avoided larger cities where the effects of modern technology tended to erase traditional culture and there was a sense of superficial homogeneity in the contemporary global inheritance. Also, in the hopes of reducing the tension I felt as a photographer with a valuable camera, smaller communities provided more safety and a slower pace that suited my own. There, I was less nervous about approaching a stranger with a request to do a portrait.

Several years after the birth of my children in the 1970s, and after a divorce, in 1980 I traveled to Nigeria for the first time. I returned four different years for monthlong visits to the same Fulani villages in northern Nigeria. I stayed with the International Livestock Center for Africa (ILCA) group and occasionally with Ladi and her grandmother in their *ruga*, the encampment of the seminomadic Fulani. Their small, thatched-grass house was round with a fire in the center of the interior, which enabled the smoke to pass through the grass structure and easily maintain warmth, cook food, and chase mosquitoes all at the same time. The mats on which we slept were woven from local grasses.

Once, rising very early, I heard the familiar pounding of sorghum and, emerging on my knees through the low opening of the hut, I looked up and saw Ladi's head framed by the huge sky (Plate 24). From this angle, her elegance and nobility were so striking that I speedily took up my camera, guessed at the exposure, and clicked several times, not even stopping to measure the light. Fortunately, the Hamatan, a sand mist blown from the Sahara by the north wind, had hazed the sky, and the glare was subdued. The image of Ladi, I feel, speaks to her youthful strength in the face of a difficult and precarious life.

In the case of Antigua and Nigeria, I returned year after year and really got to know the people well. Perhaps this is why portraiture be-

came so compelling to me. I began to grow as an artist and to see the value to my work of visiting other cultures, not necessarily for extended periods. I loved the subtleties of different phenotypes, varying ways of moving and living, diverse modes of dress. I was captured by the form of a child leaning on a mother, hands reflecting a long life's work and the unspoken but discernible bond between a husband and wife—all reflecting a part of the intriguing mystery of who they were and how they survived. Antiguans, Nigerians, Brazilians, and then later in my career, Italians, Spaniards, Mexicans, and Norwegians, and then much later still the Thai, Cambodians, Moroccans, Native Americans—it was always the people themselves who drew me in. No matter what their landscape —mountain or desert; no matter what their house—grass or adobe; no matter which religion—Muslim or Christian; no matter what culture— Caucasian or African, each individual had a unique complexity. All had a history.

In the 1990s, for the first time in my career, I experienced a creative dry patch. I became tired of everyone's story. For a few years I produced almost no new work, the photographer's equivalent of writer's block. I was not interested in traveling or meeting new people or making portraits. These were very uninspired years for me. The challenges of family life itself demanded attention, and the financial requirement to do commercial work absorbed too much time.

Finally, though, I began to experiment again, this time with Polaroid transfers. I made color slides of flowers and trees, copying them onto Polaroid film, and then transferring them onto watercolor paper using the chemistry in the film packet. I loved the muted tones and the mysterious feel of the results. The images suited my darker mood and my then desire to stay within myself. I started reading most of Joseph Campbell at that same time, and some Carl Jung, and writing more in my diary about my dreams. As a playing field, I used an antique mirror that came from my childhood. I placed plants and seaweed on it and photographed. I photographed my daughter's face and sandwiched the negatives with those of the plants and seaweed. I used masks that I got from a tribal arts store in town. They all became symbols for my own nightmares and my own inner journey. With my living room as a studio, I was content working by myself. This series I titled Mythscapes. It would be a while before I again opened a window onto the world outside.

When I did start doing portraiture again, I understood that I had been searching for more intimacy in my approach. Having connected more deeply with myself, I now wanted to understand even more about the "other." But, in the same moment how does one get closer with a camera and less invasive at the same time? Diane Arbus is correct—that

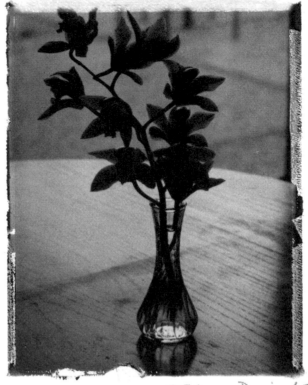

Orchid at Dusk, Polaroid Transfer, 1994

we are nicer to each other without the intervention of the camera, that the camera makes us colder and harsh. It is precisely this issue that I struggled with: trying to find a warmer, gentler approach with my camera.

My solution is that with my Hasselblad I have chosen to work without a prism finder because the prism attachment lifts the camera to eye level, interrupting a direct line of sight to the subject. Instead, I prefer to look down into the viewfinder, leaving my eyes unencumbered to look up at will and make a direct connection with my subject. The camera itself then becomes less obtrusive and melts away into the background of the process. The camera is a scrutinizer, but at waist level, it is less so. When on a tripod, the camera is also away from the photographer's face and therefore less interruptive. Intense reflective moments, like the one of the monk at Angkor Wat (Plate 54), in which he is clearly having a serious dialogue with himself, are a challenge to photograph without disturbing the subject's feelings and process.

Like Arbus, Henri Cartier Bresson, Susan Sontag, and others have remarked that photographing people is something appalling, exploitative, invasive. In an attempt to be less so, I always ask permission of those I approach. Nonverbal communication precedes any attempt that I make to speak with a stranger. I smile, try to summon good feelings, and build positive energy. With no language, I point to the camera for permission; if I am refused, I move on. With luck, eyes connect and hearts reply. I think to myself: we shall create this portrait together. We are partners in this endeavor, like a call and response—trying to lay down on film the subtleties of human emotion so complex: confidence, pride, joy, sadness, defeat, vulnerability, skepticism, defiance, or fear or whatever the moment's feeling happens to be.

It would be easy to become sentimental and over romanticize these encounters, to pretend that they are all special, memorable moments with fascinating stories attached. Some were relaxed, and we shared memorable hours and many return visits; some were short and more formal, less amicable. The only truth is that the reality of the photograph is very slippery, very elusive. Ladi photographed by someone else is a different Ladi than the one I photographed. Even Ladi photographed by me at another point in time and in a different light will be a different Ladi. I have no clearer words to express this subtlety, but I express it in my work.

A portrait that has the power to truly look inward can shake us up and make us question our assumptions. Like the finest literature, a powerful photographic portrait permits us to leap into the other's mind and heart. At this point in my life, I have discovered what I did not know at the onset, that I do share similar concerns with many who look and are very different from me. What I have learned is that the secret of identity I

guarded in high school, the one that made me unsure of myself then, probably makes me more familiar to others than a stranger to them. For me, the act of photographing abbreviates cultural distance, seeks the elusive essence, and reminds me that we all live under one sky. In the words of Martin Luther King Jr.:

"We have inherited a large house, a great world house in which we have to live together—black and white, Easterner and Westerner, Gentile and Jew, Catholic and Protestant, Moslem and Hindu—a family unduly separated in ideas, culture and interest, who, because we can never again live apart, must learn somehow to live with each other in peace."

PLATES

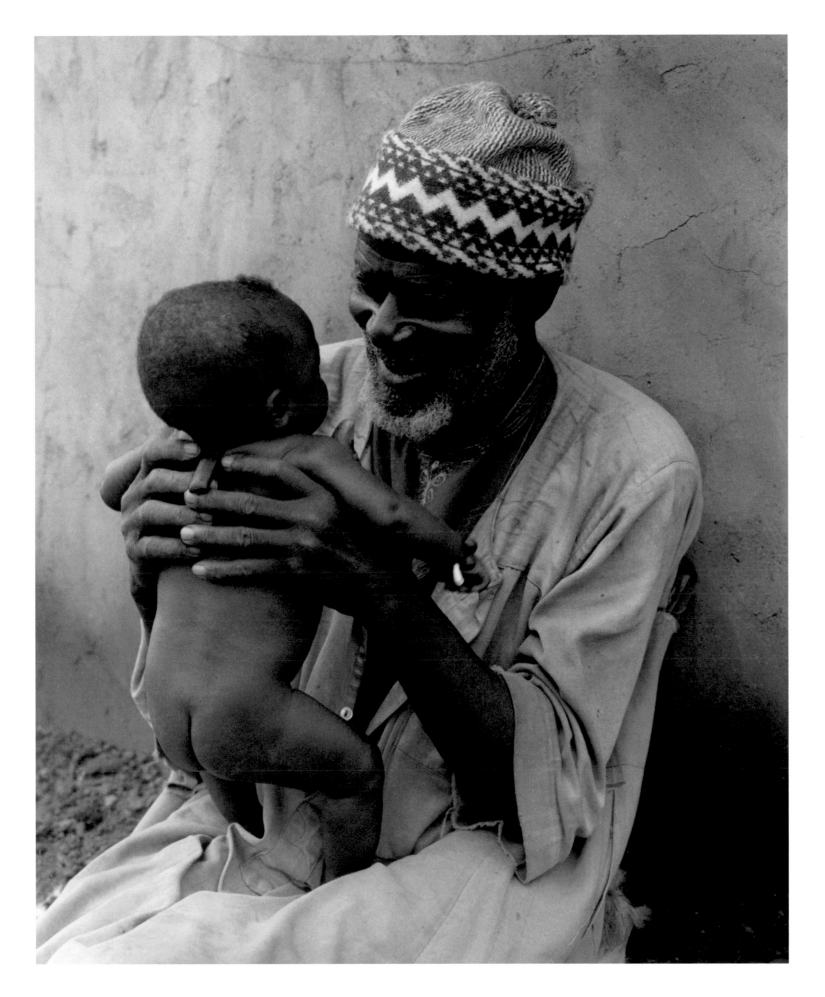

PLATE I

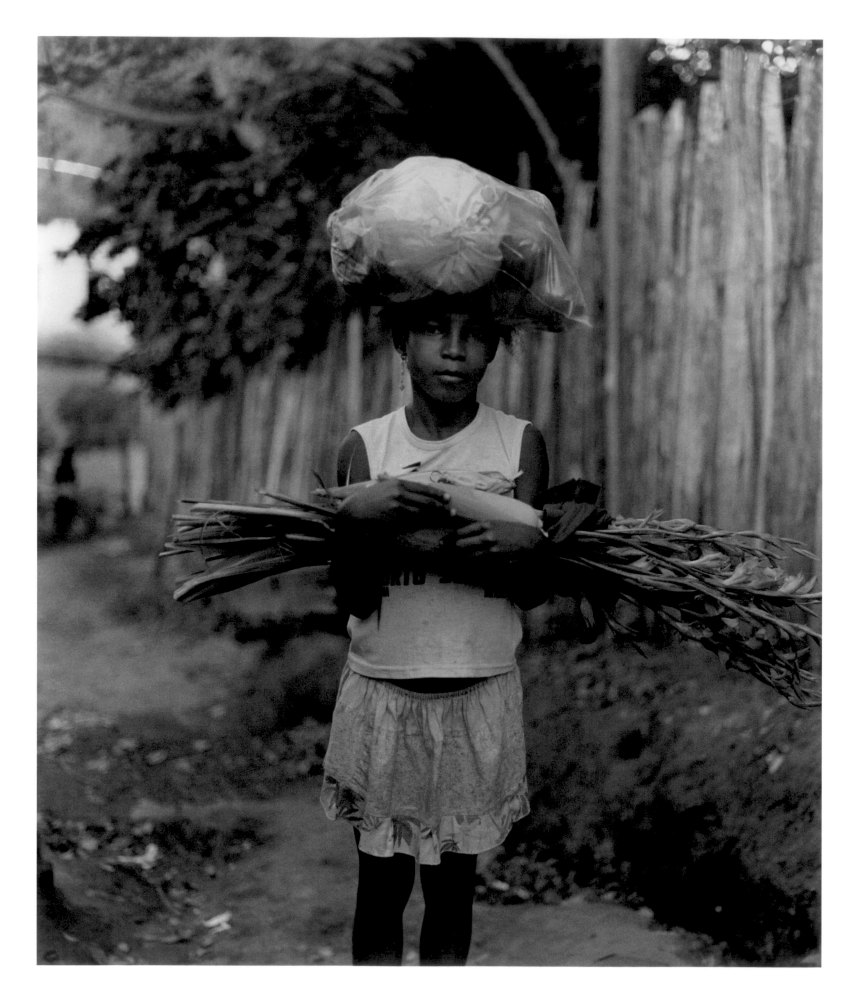

PLATE 2

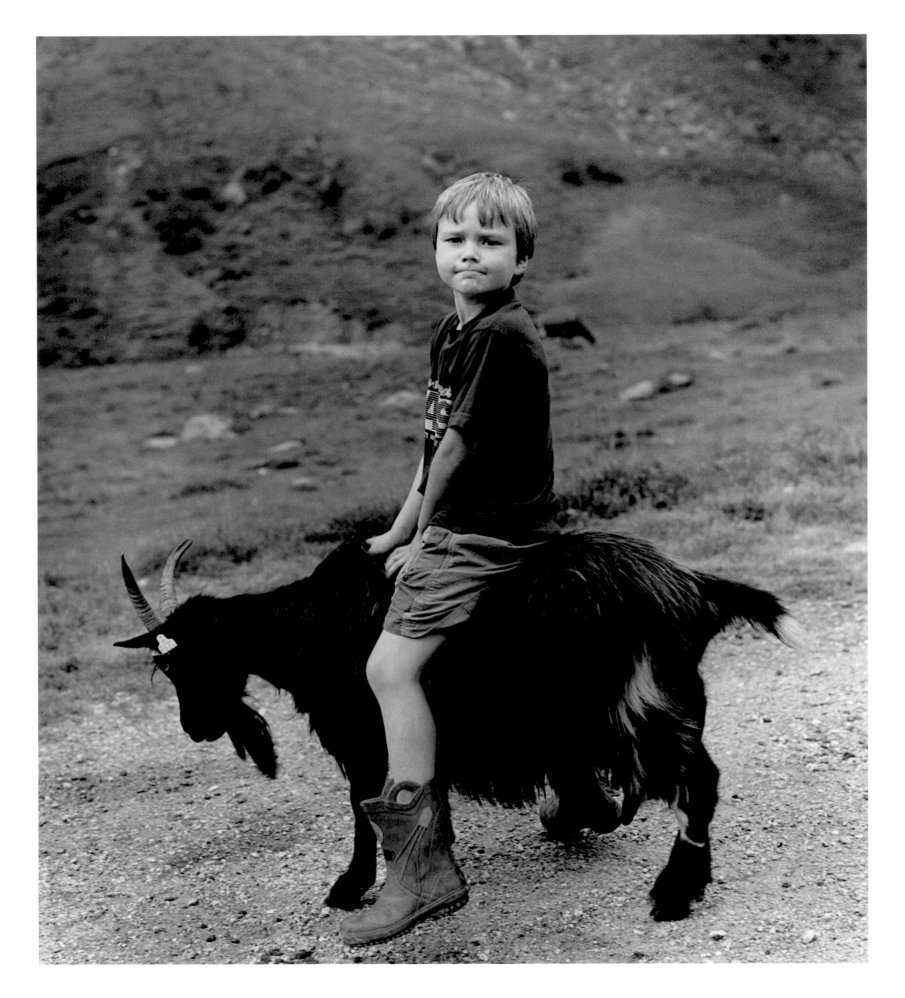

PLATE 3

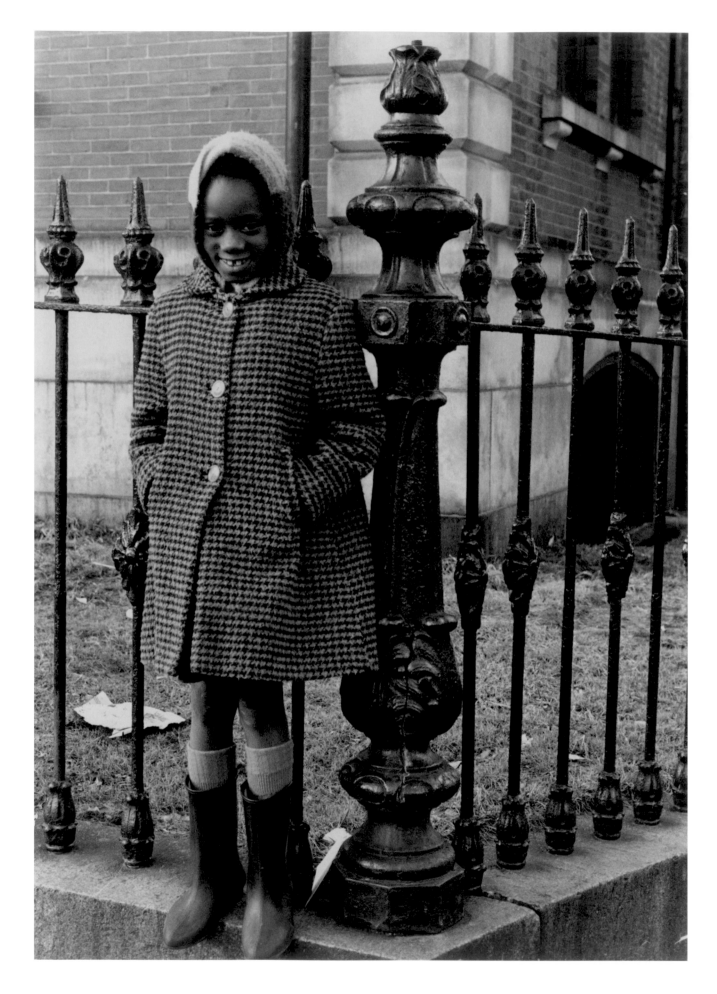

PLATE 4

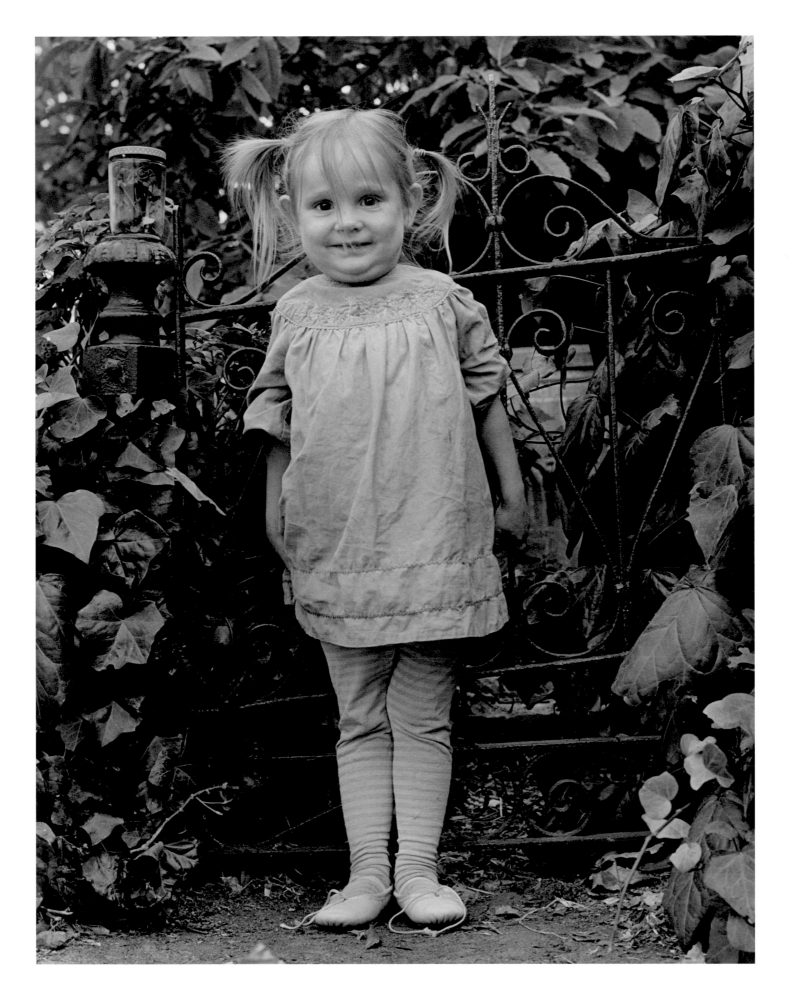

PLATE 5

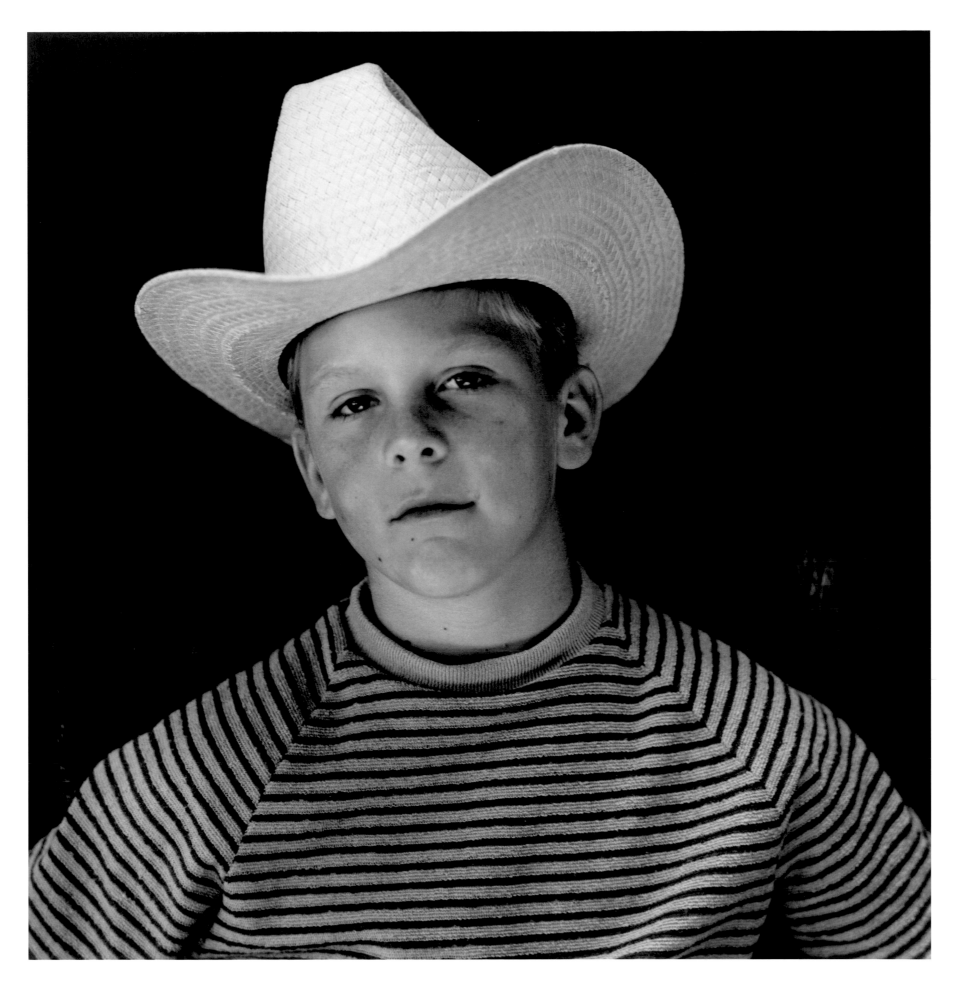

PLATE 6

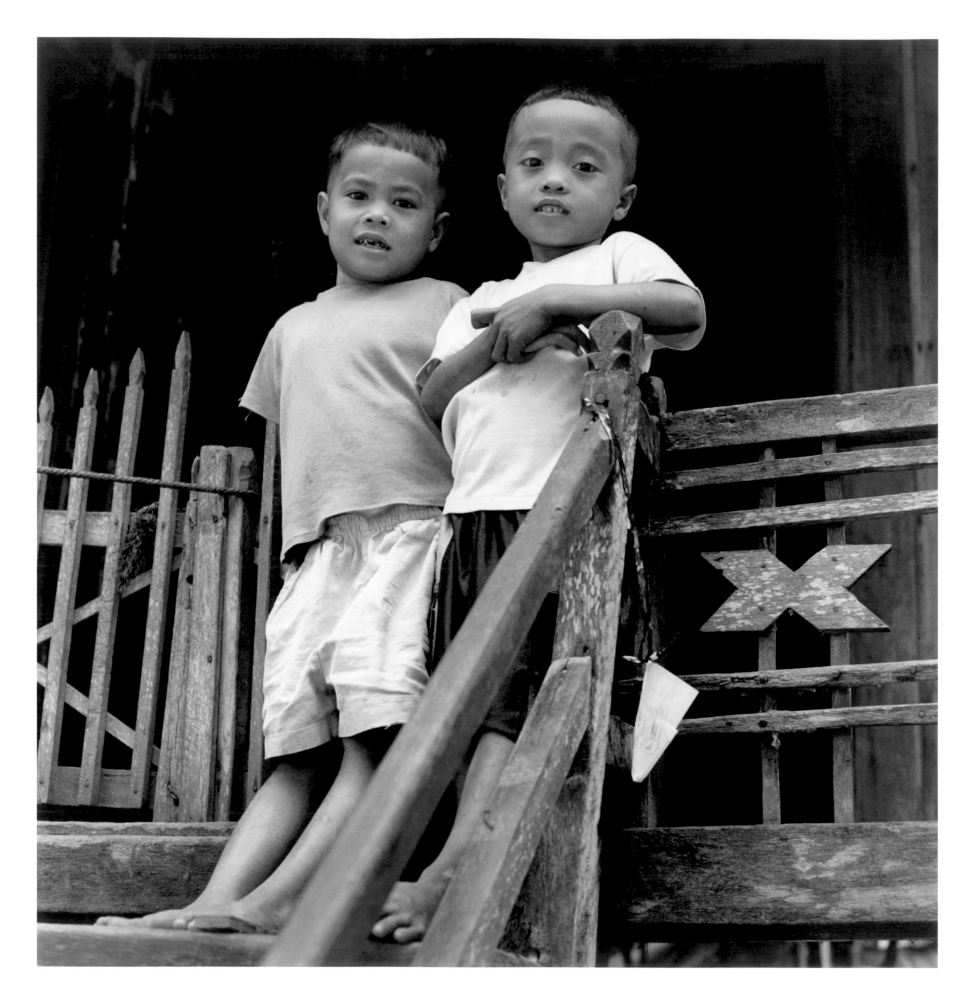

PLATE 7

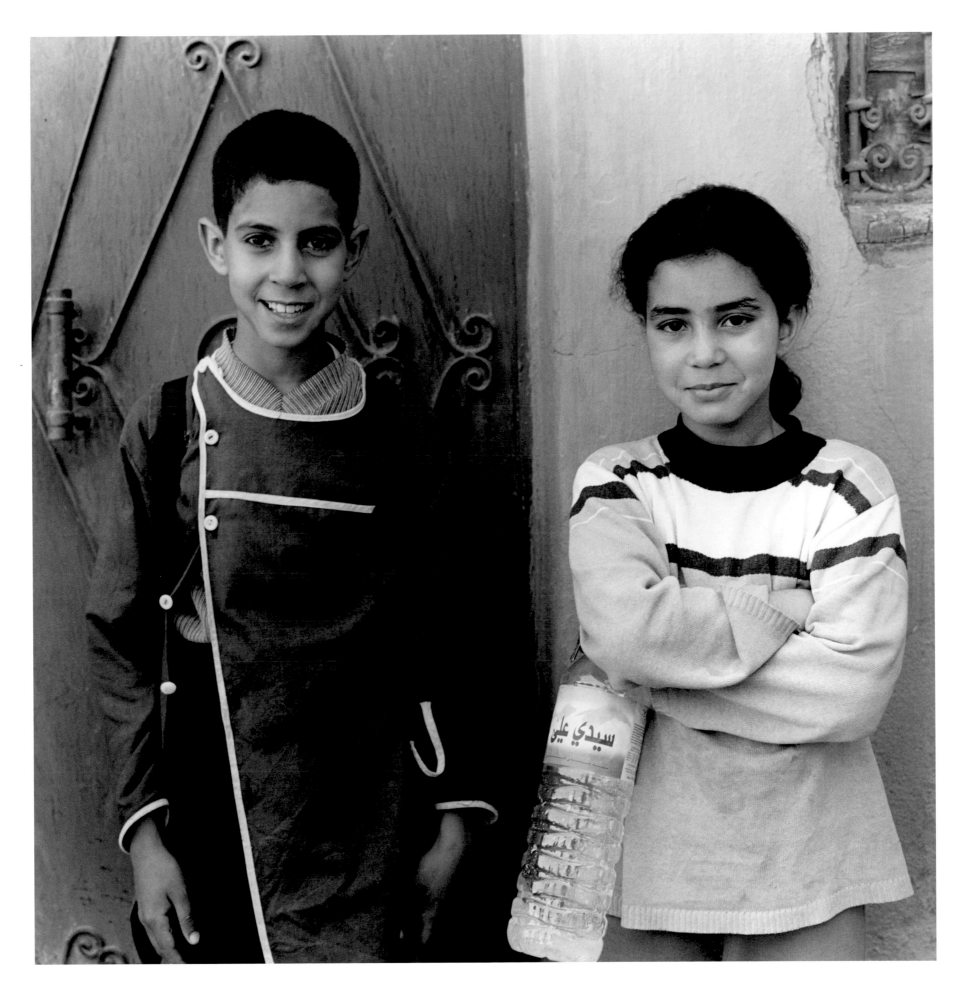

PLATE 8

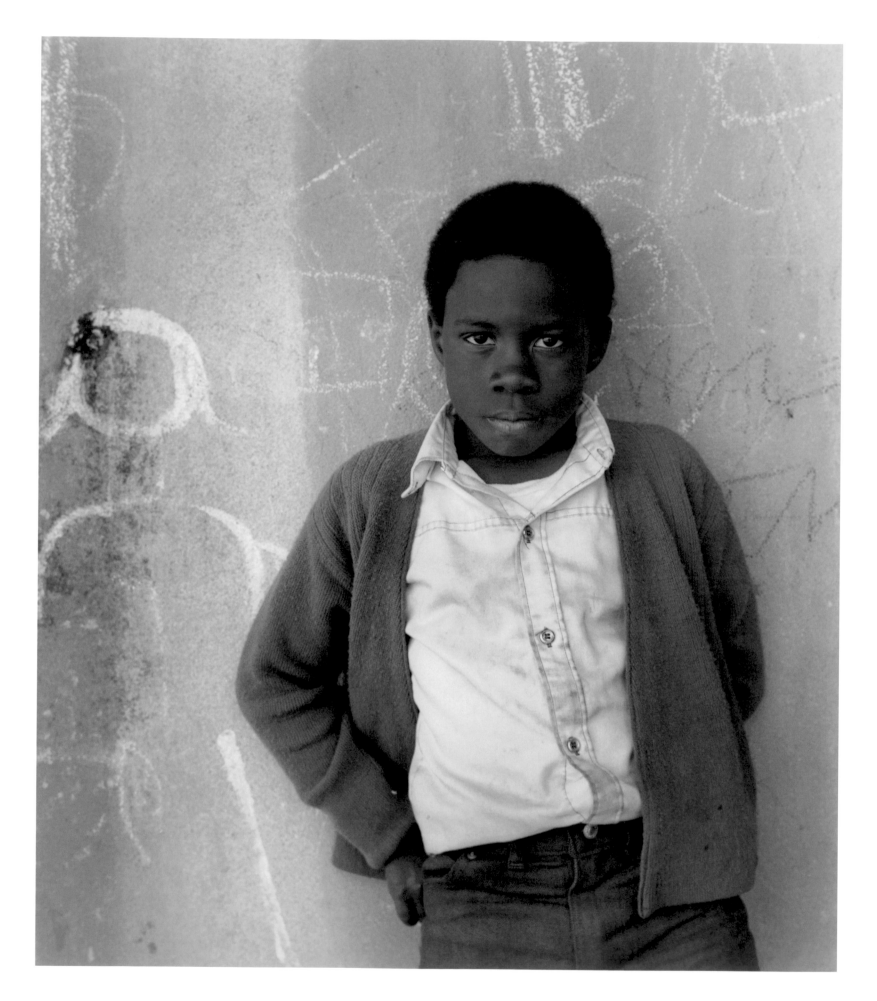

PLATE 9

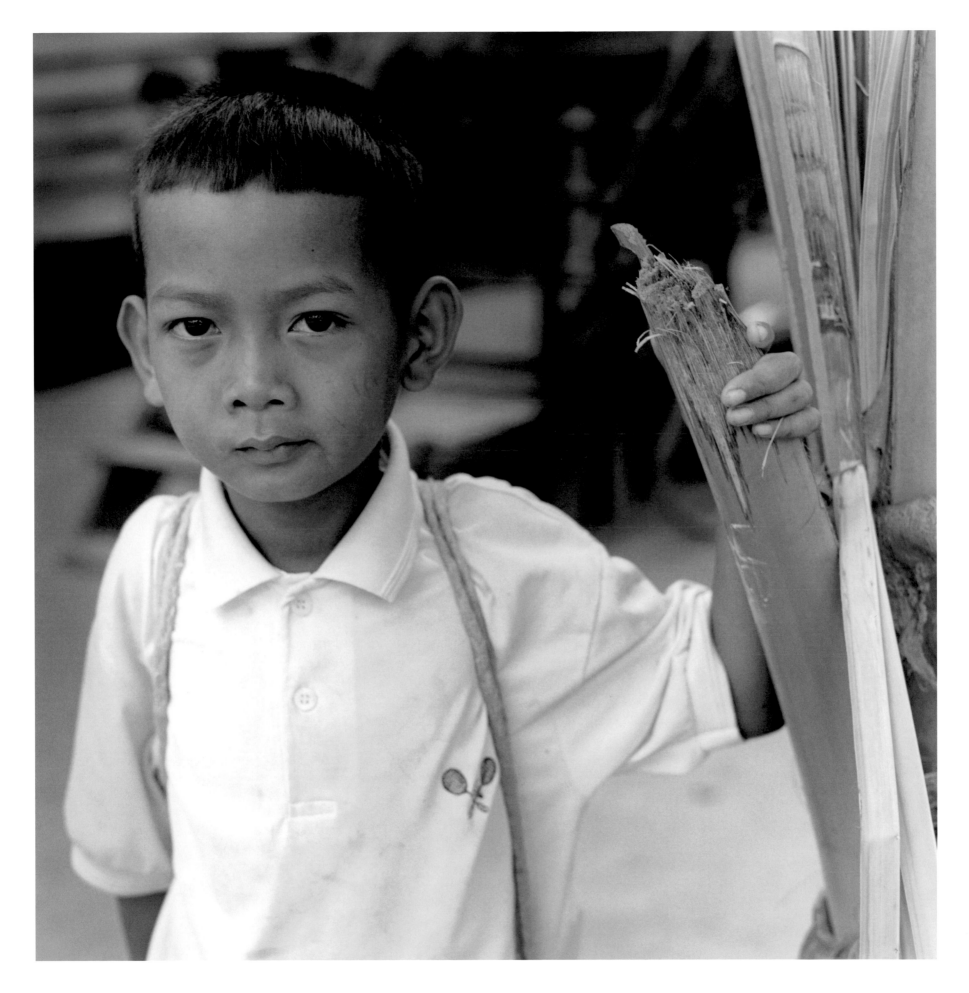

PLATE 10

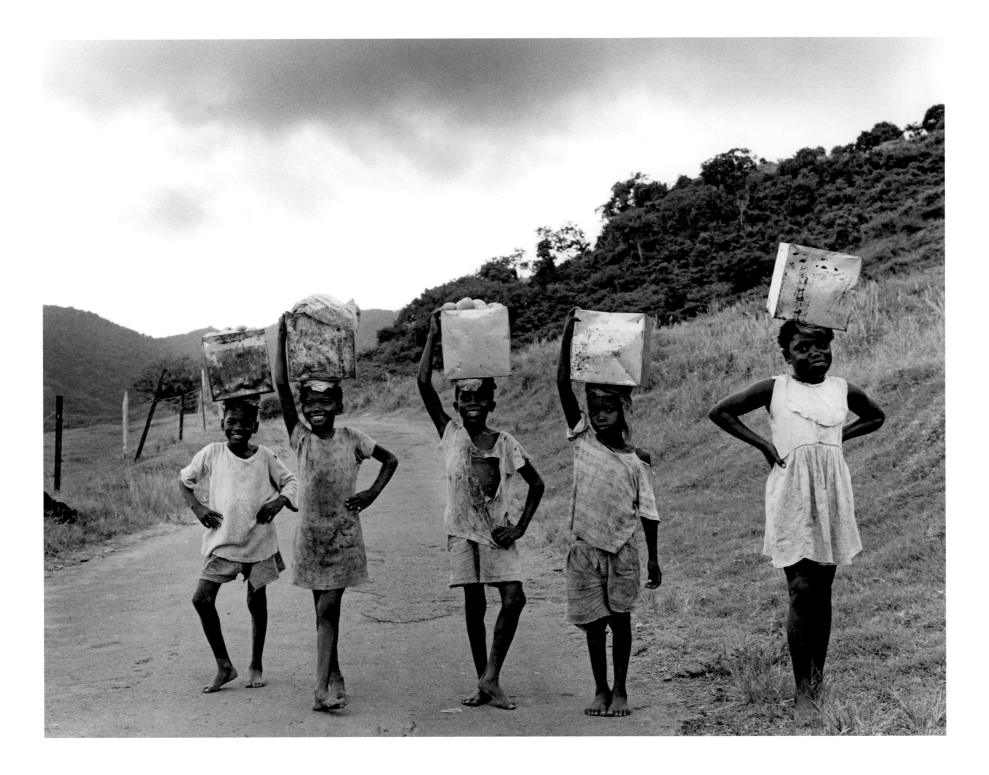

PLATE II

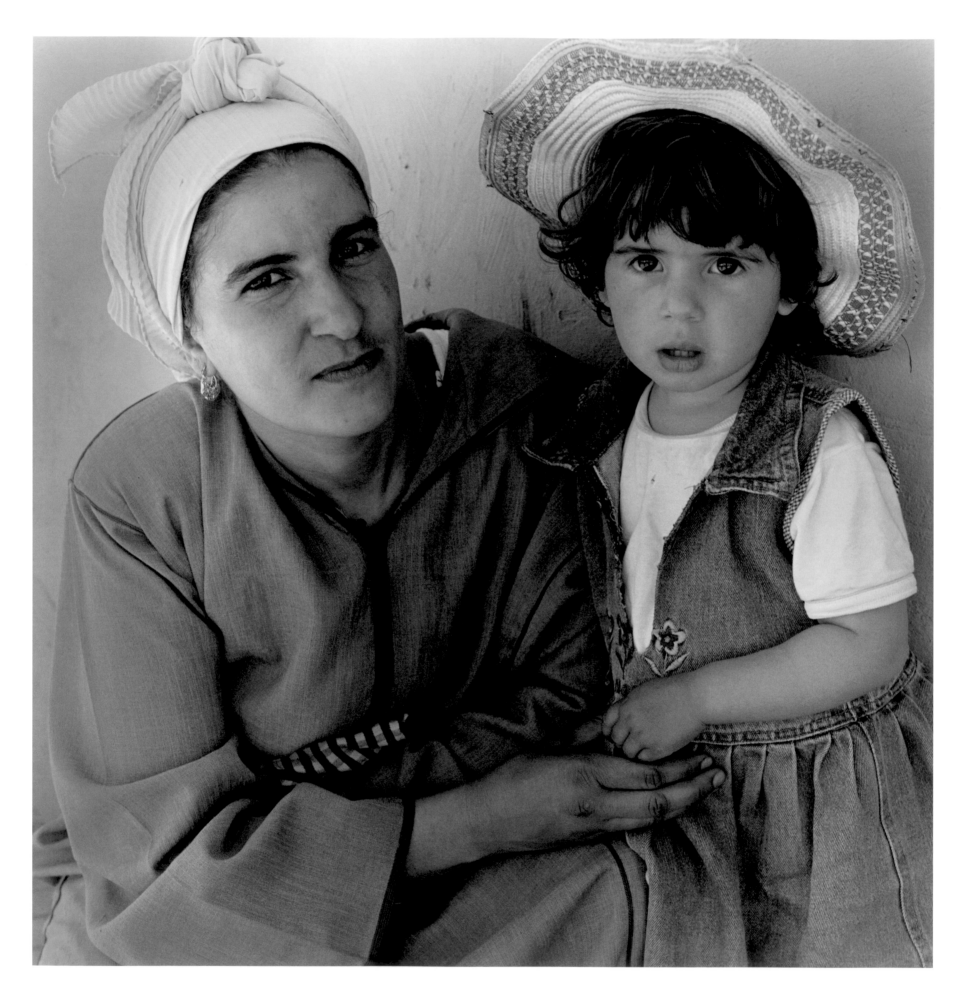

PLATE 12

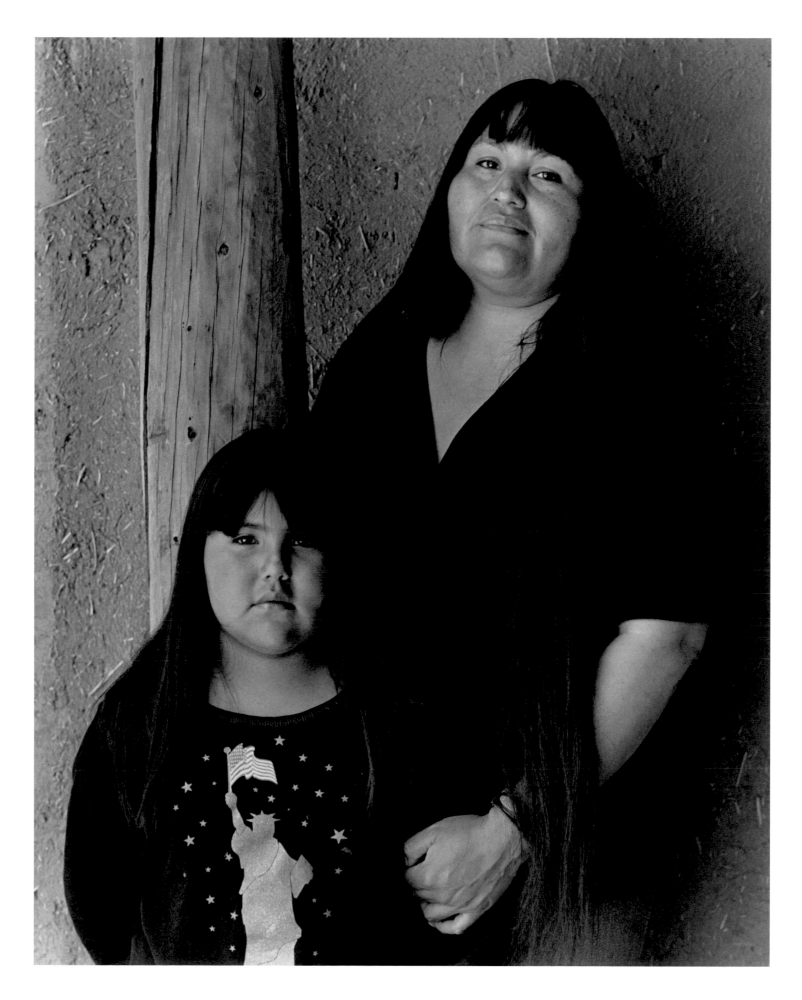

PLATE 13

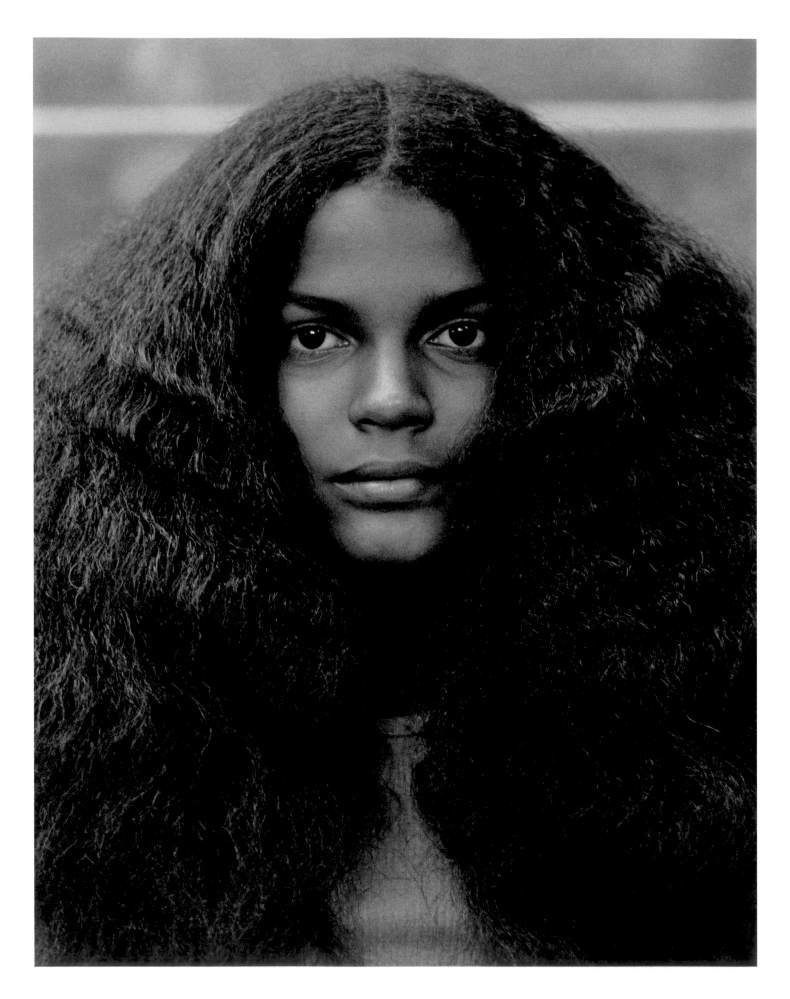

PLATE 14

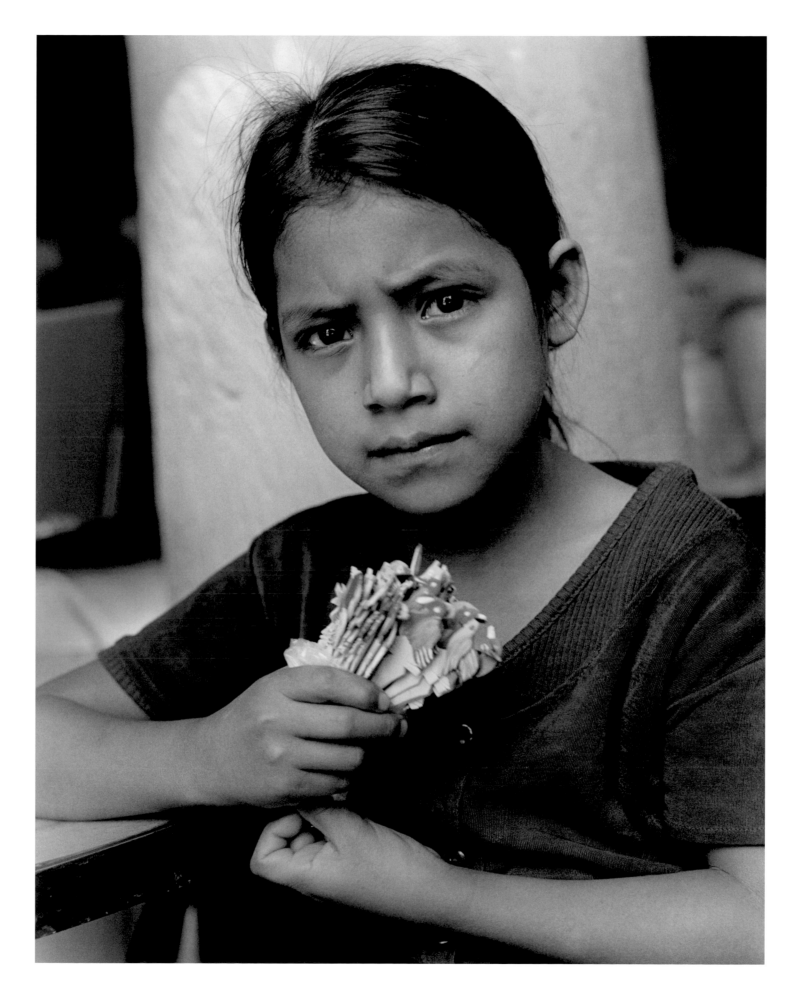

PLATE 15

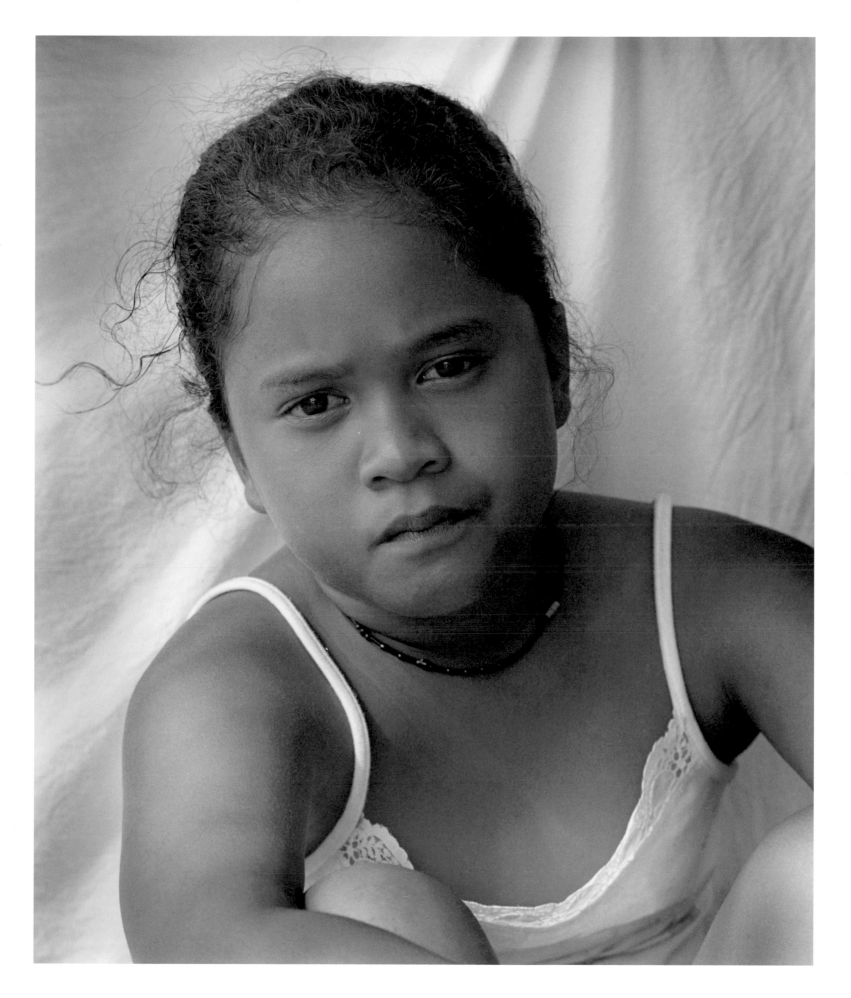

PLATE 16

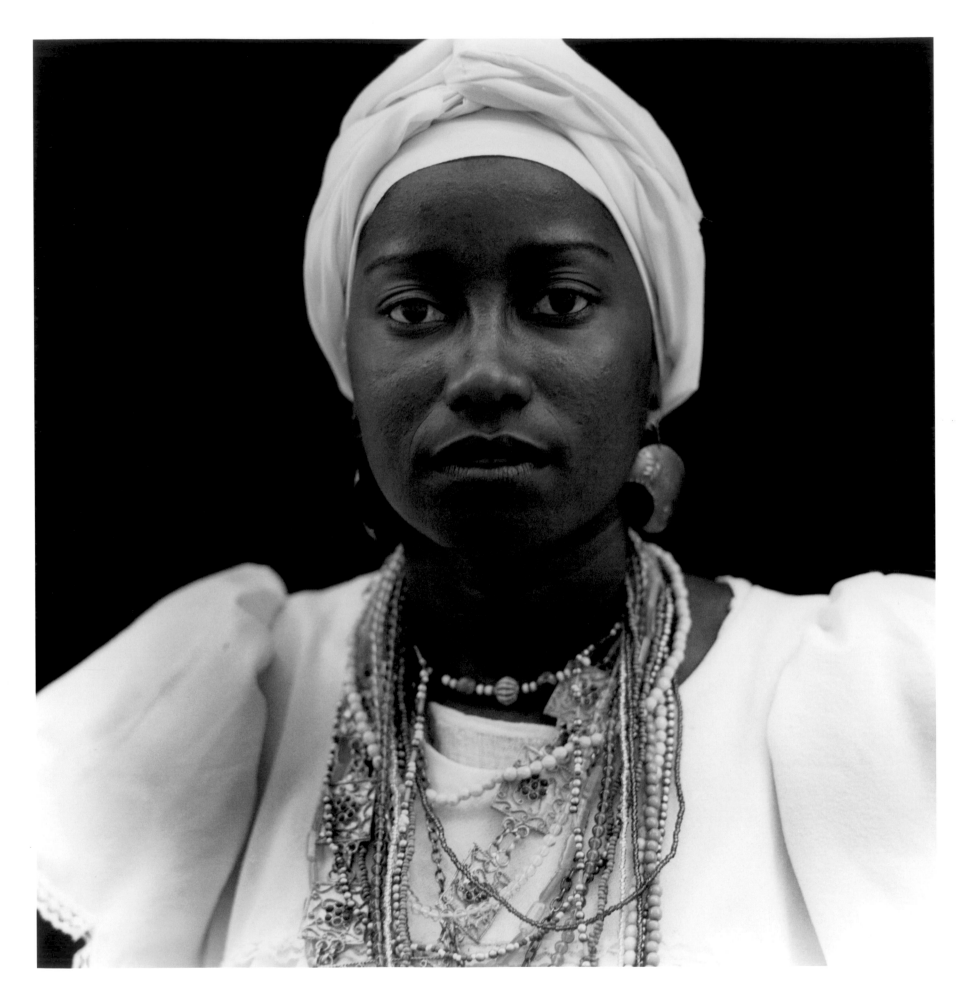

PLATE 17

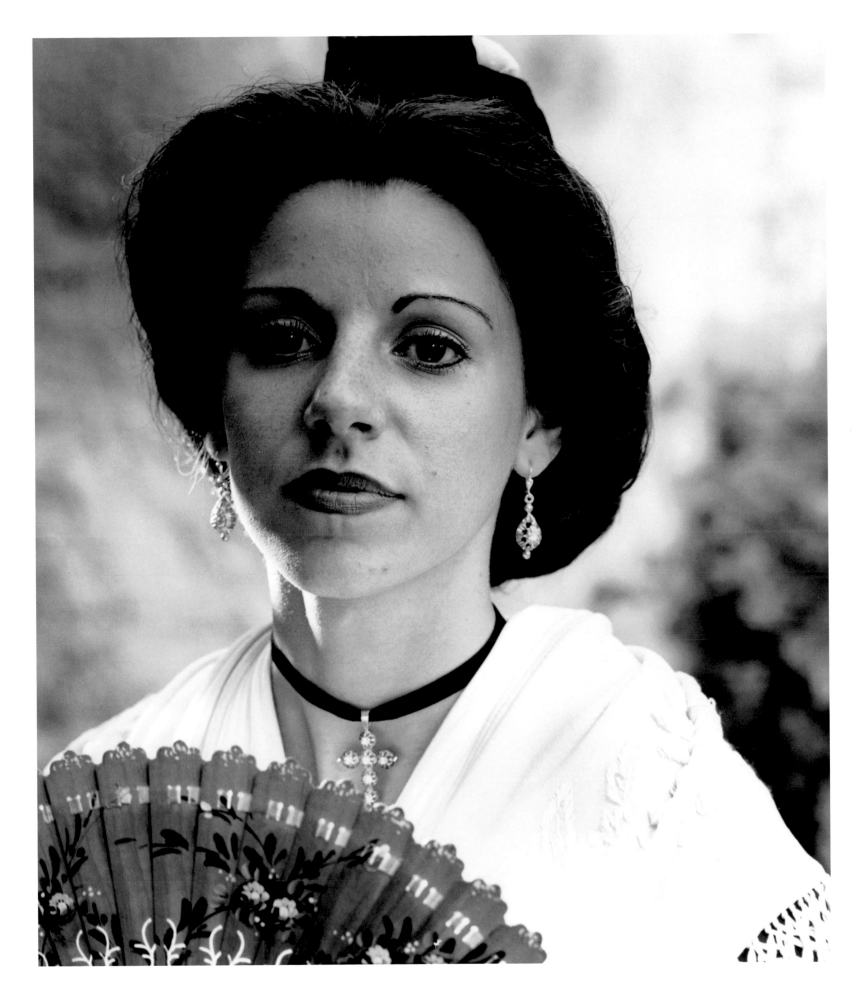

PLATE 18

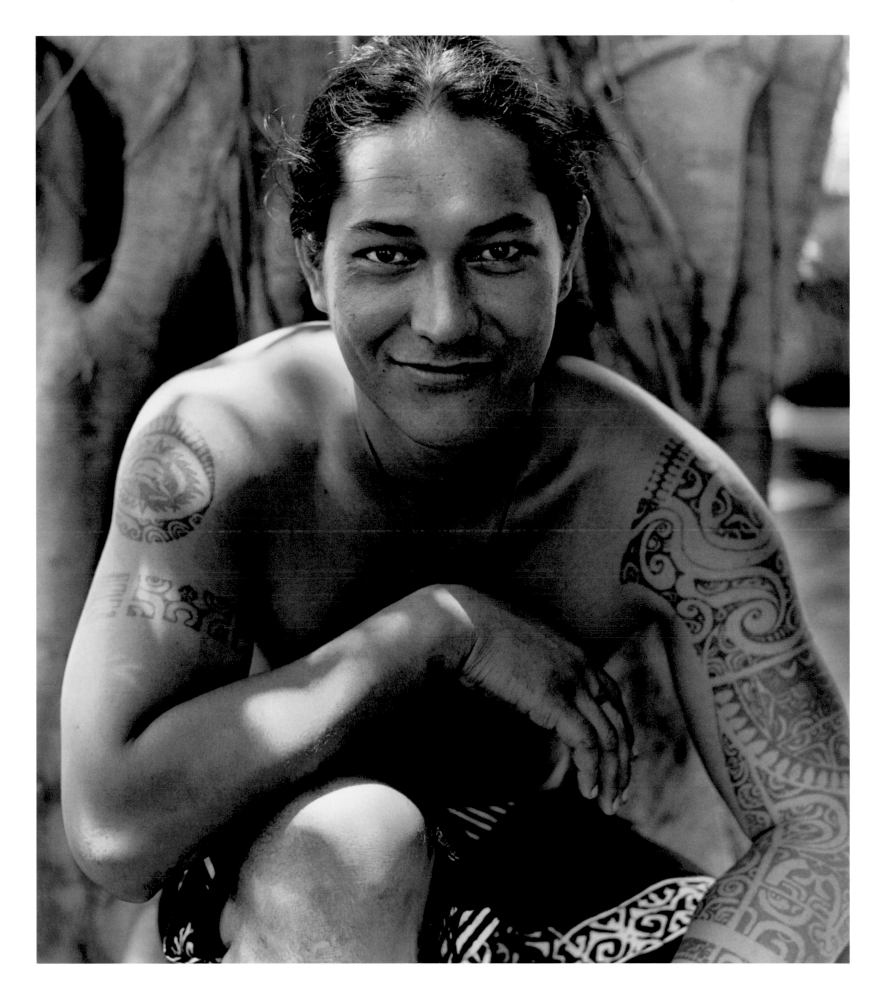

PLATE 19

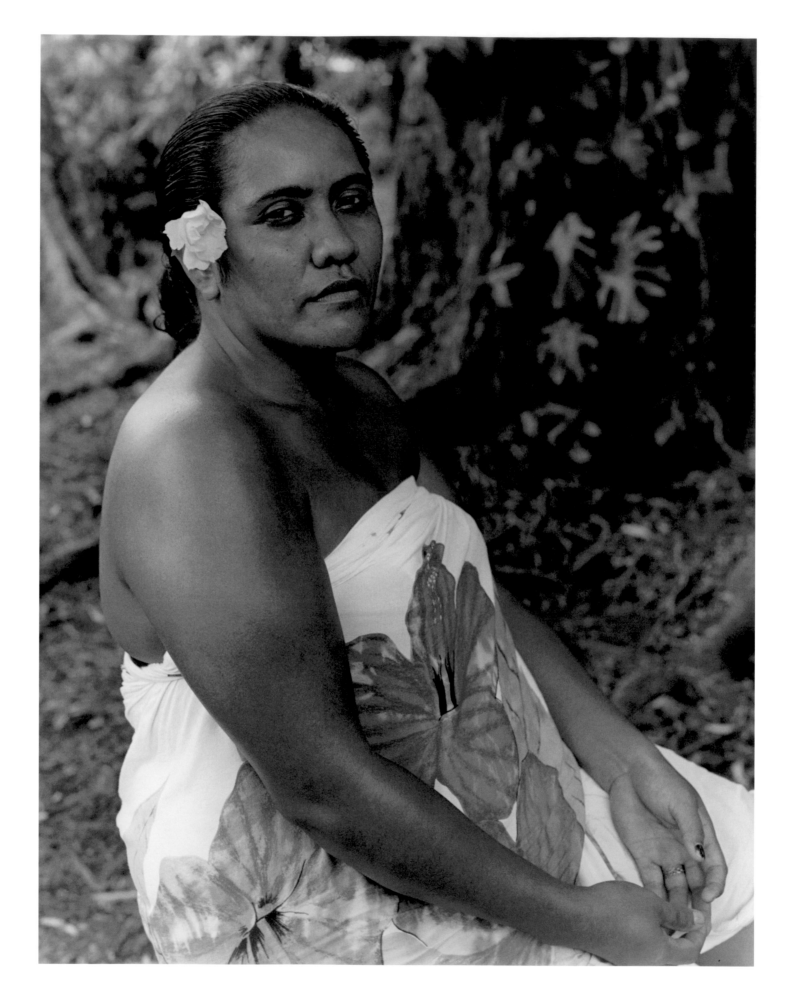

PLATE 20

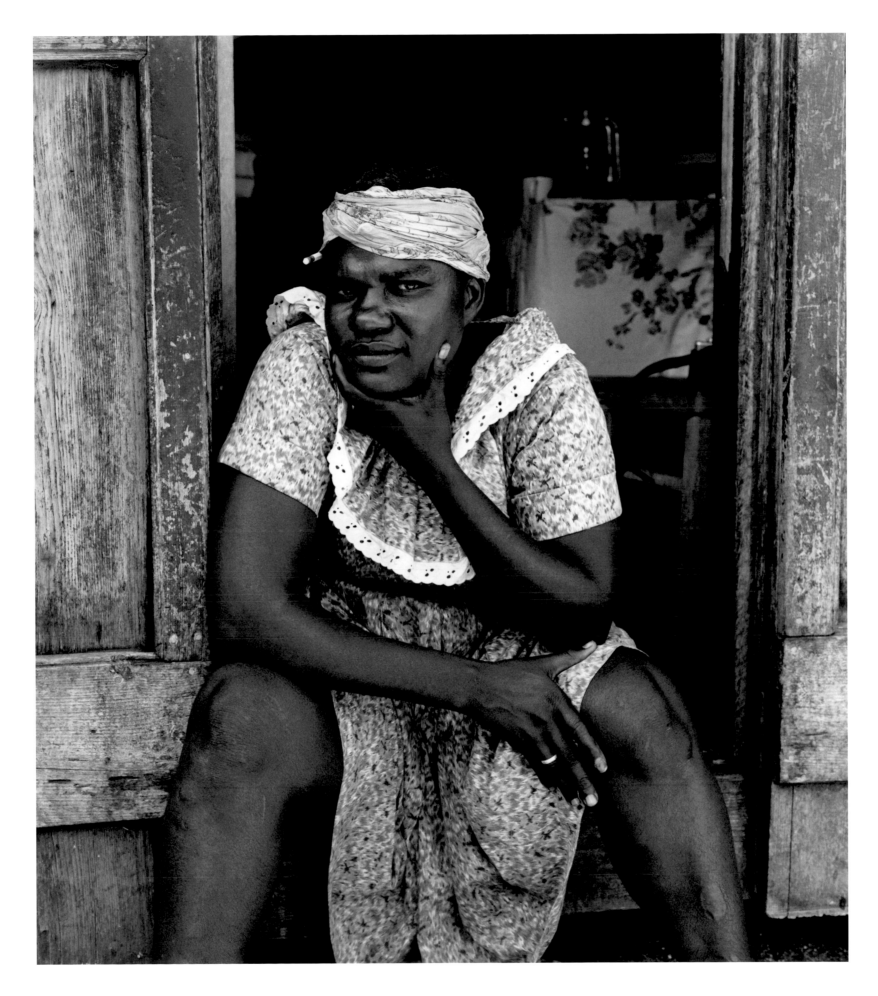

PLATE 21

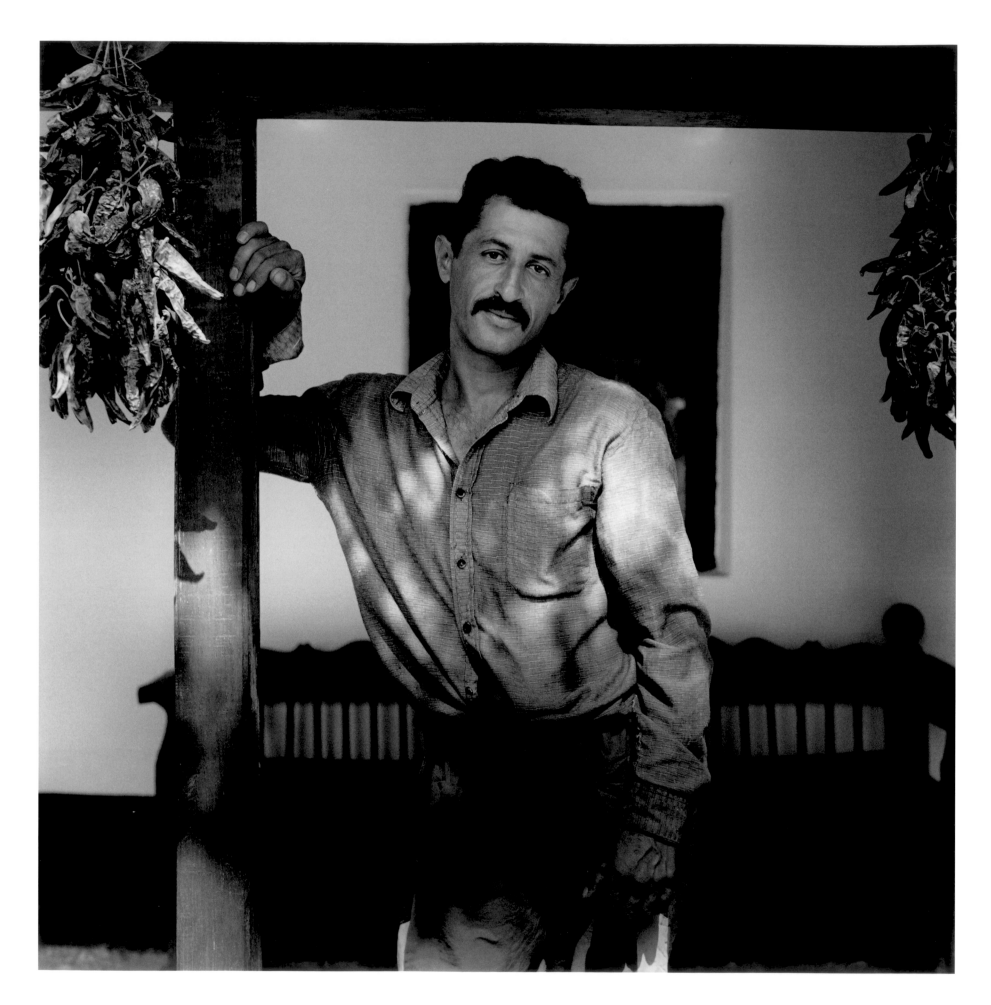

PLATE 22

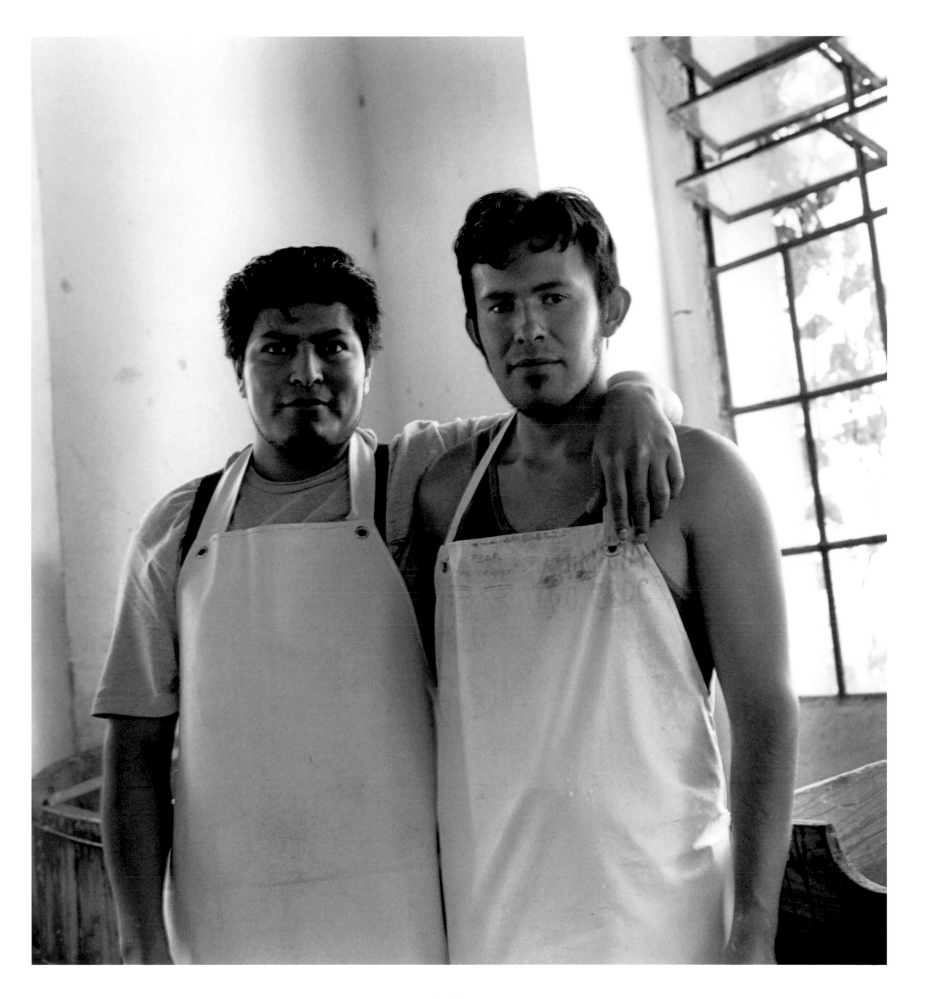

PLATE 23

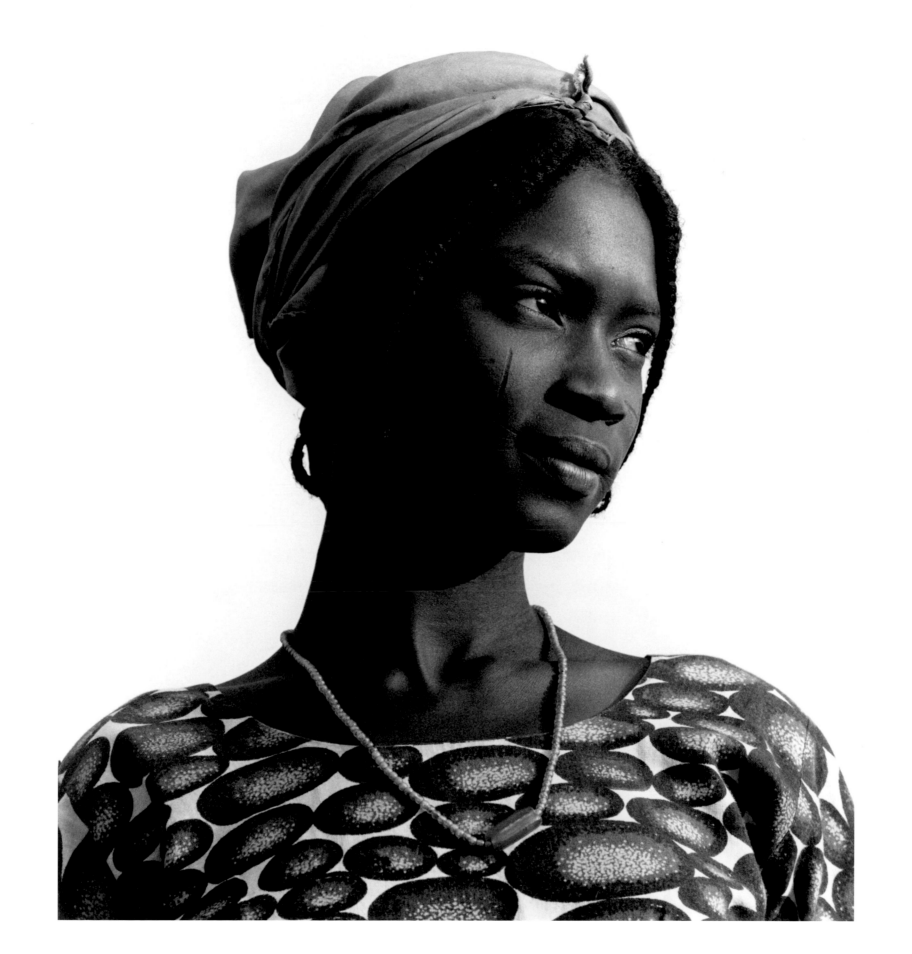

PLATE 24

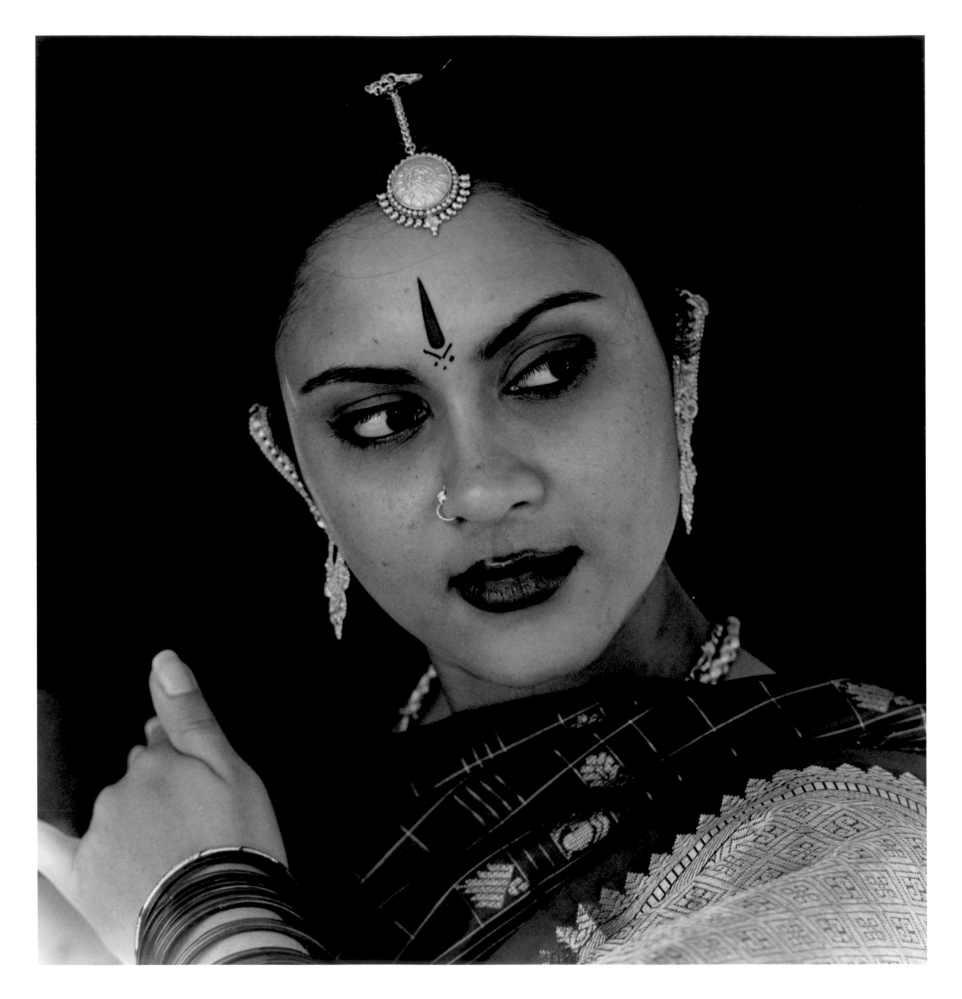

PLATE 25

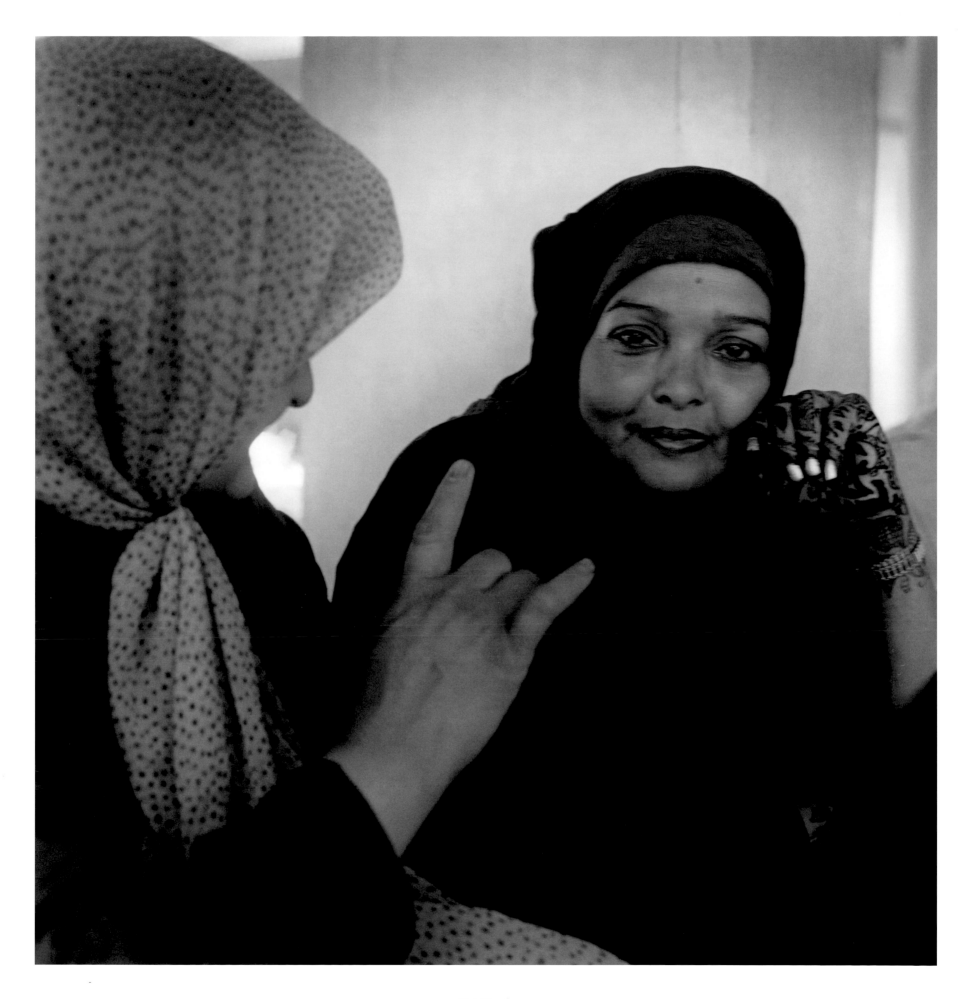

PLATE 26

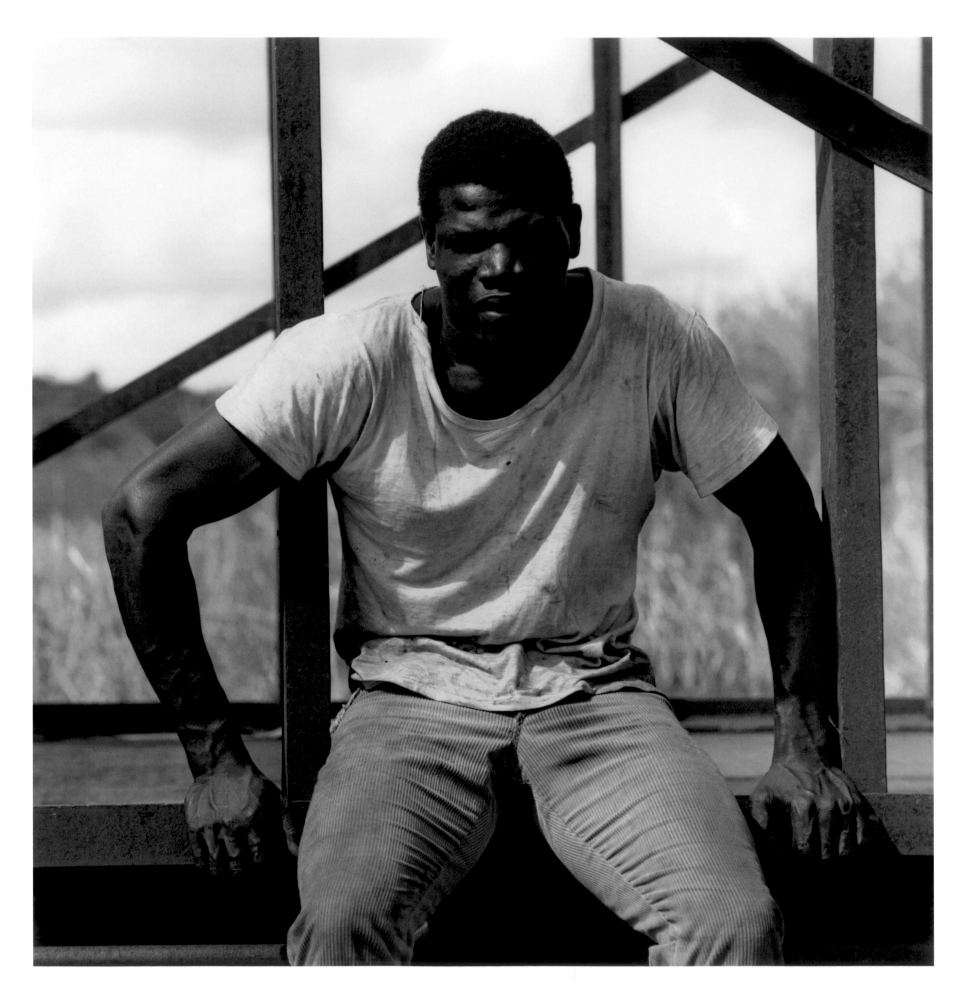

PLATE 27

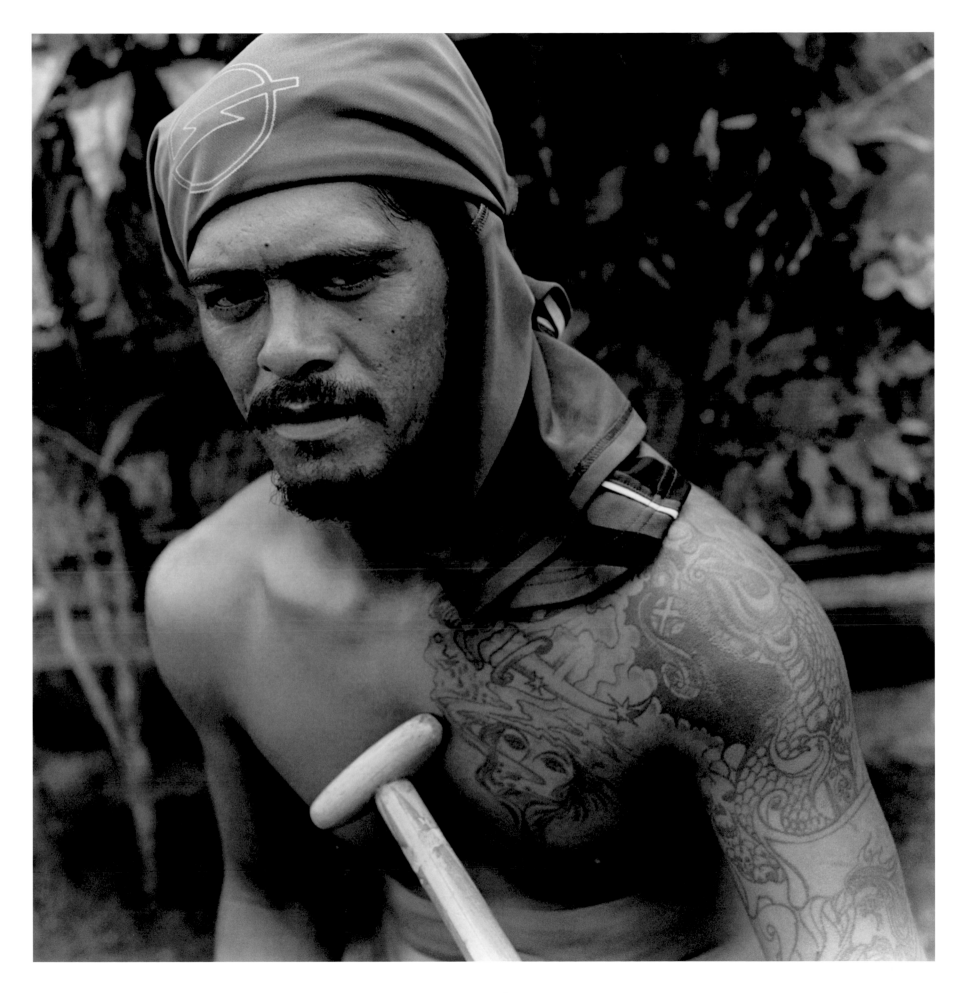

PLATE 28

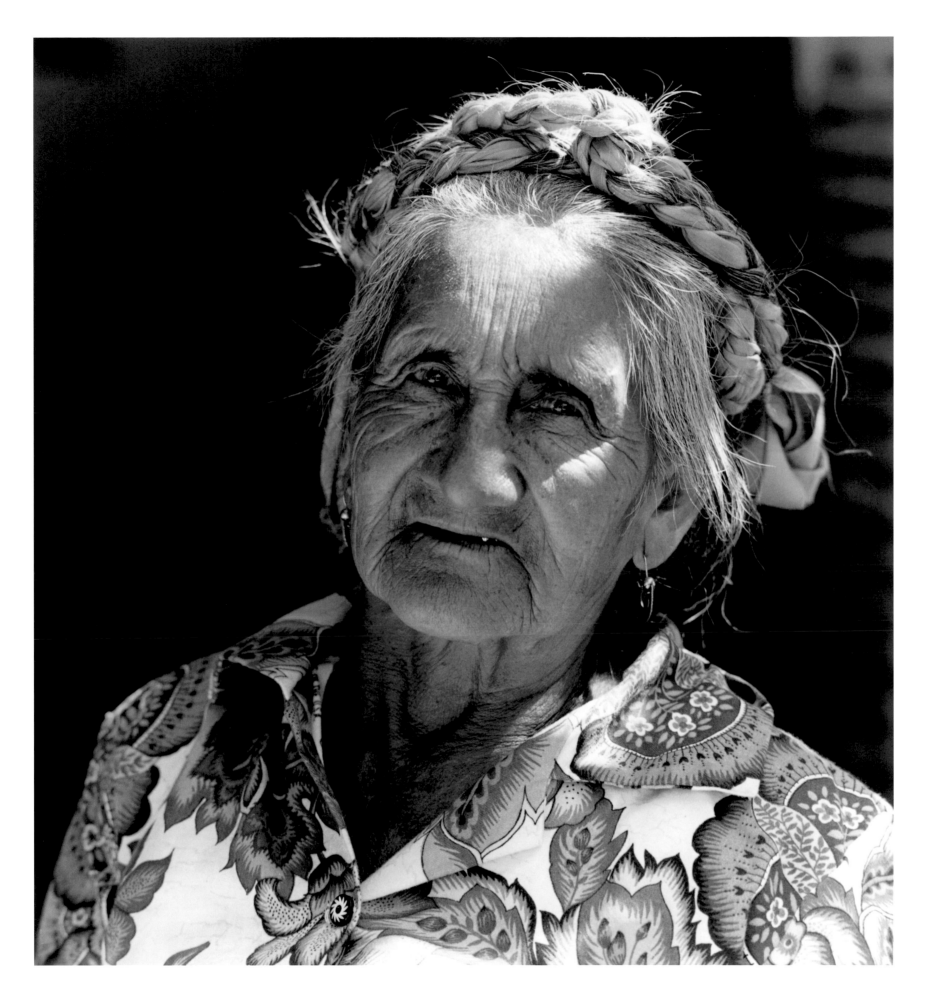

PLATE 29

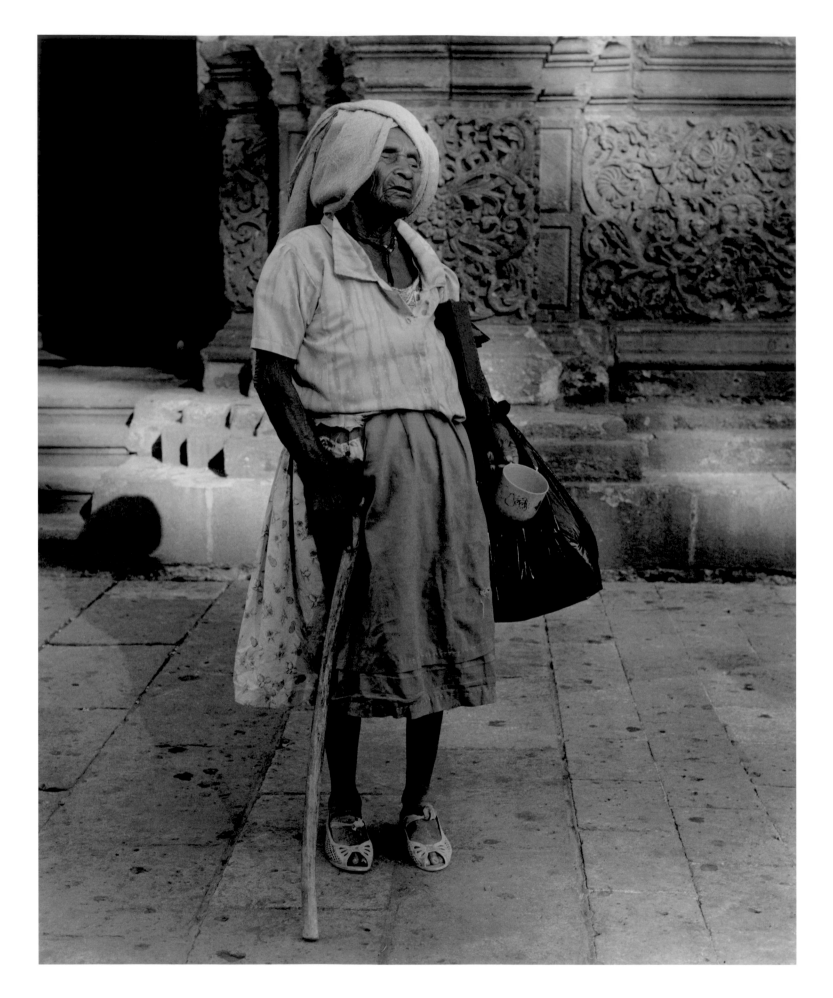

PLATE 30

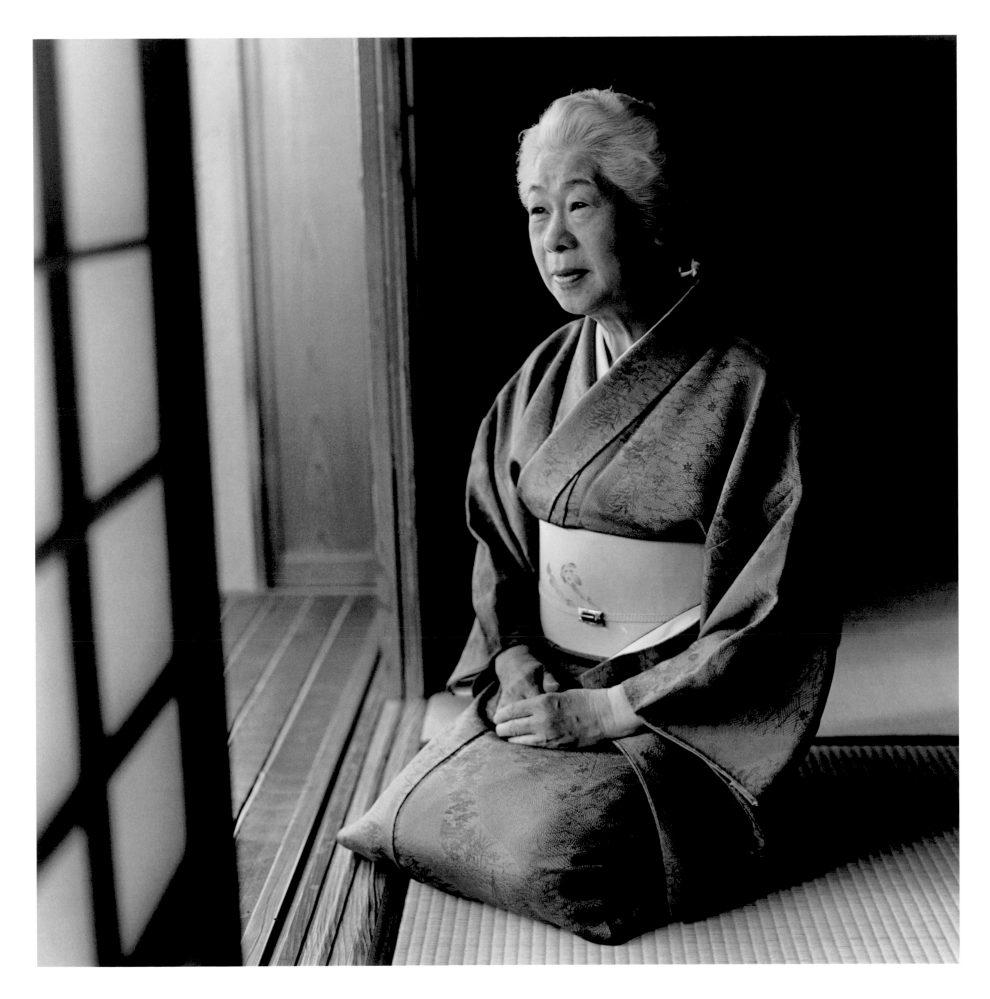

PLATE 31

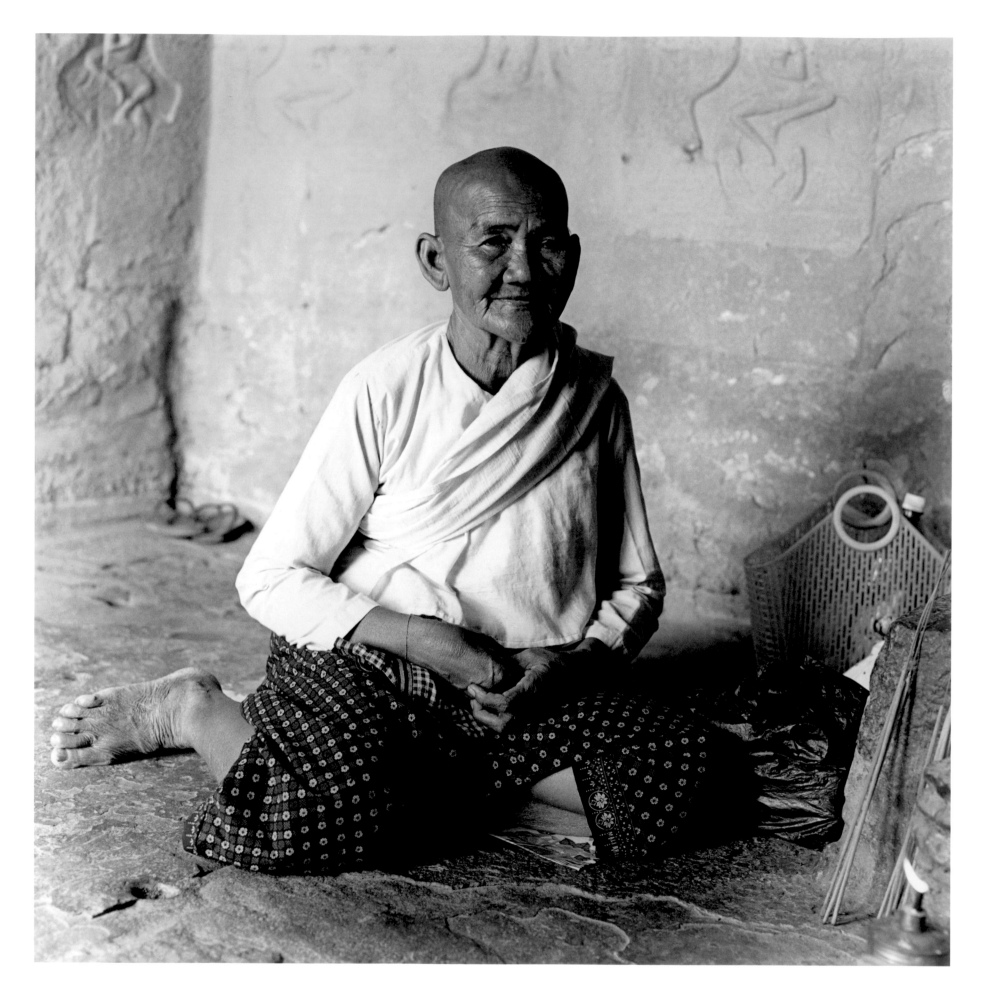

PLATE 32

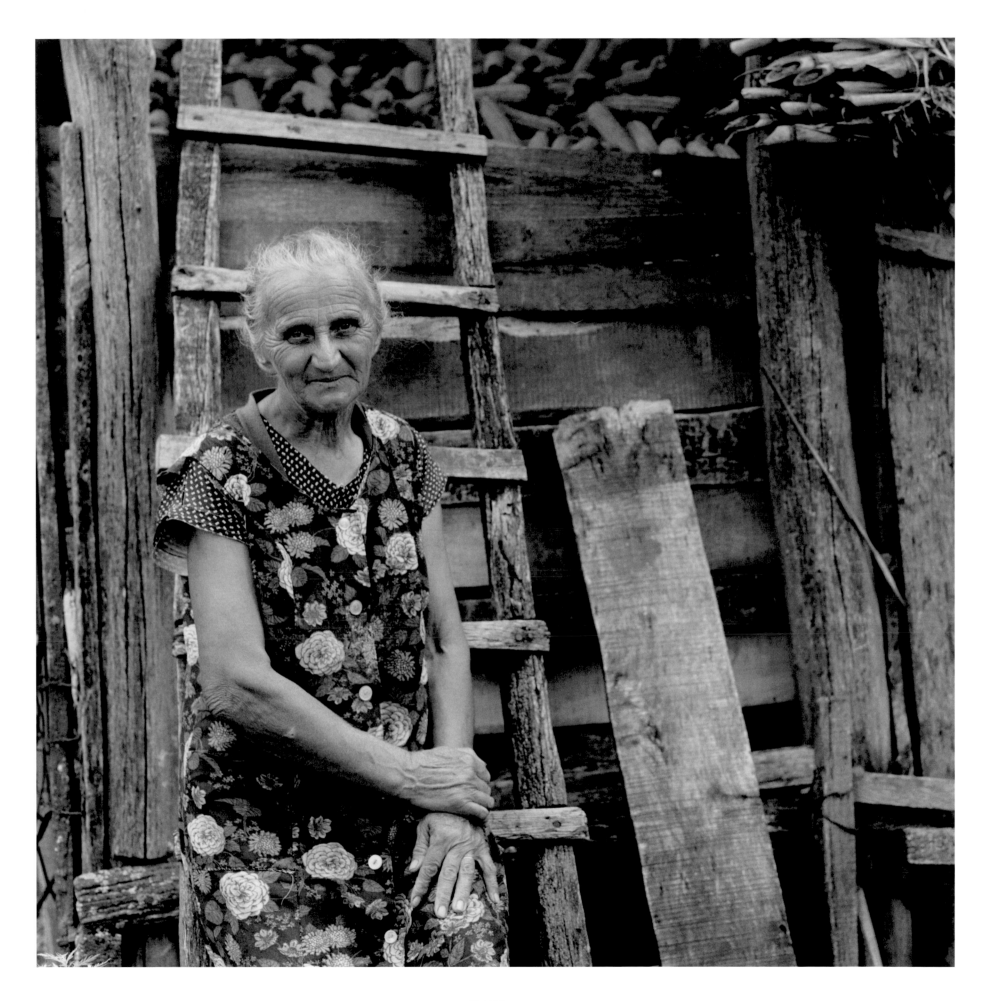

PLATE 33

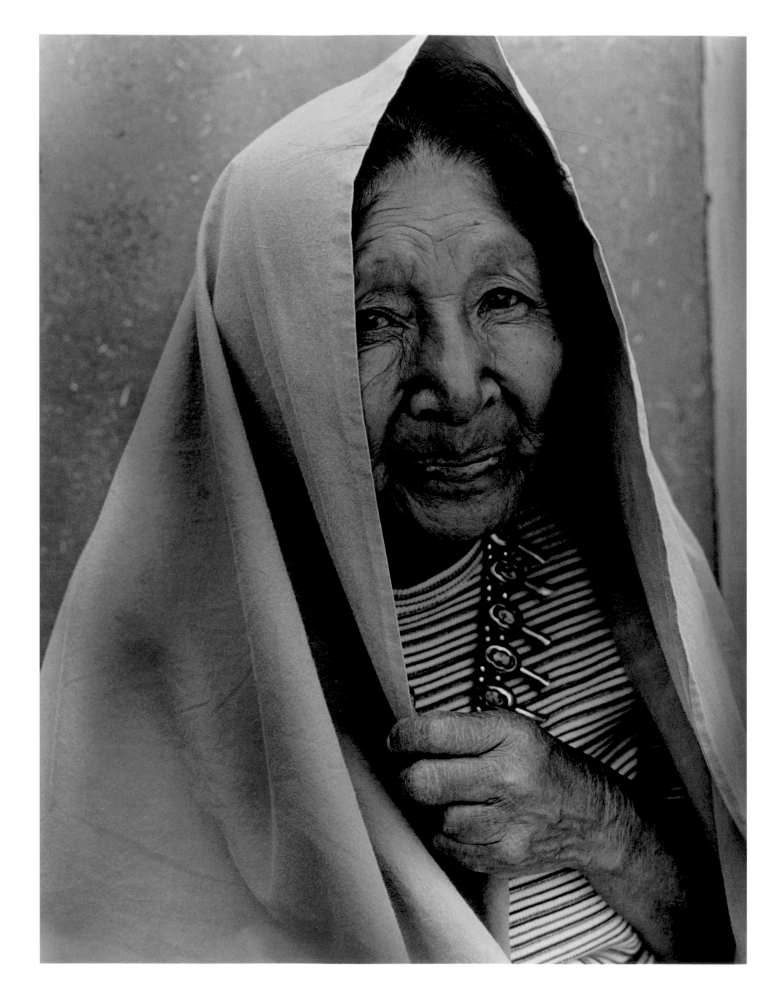

PLATE 34

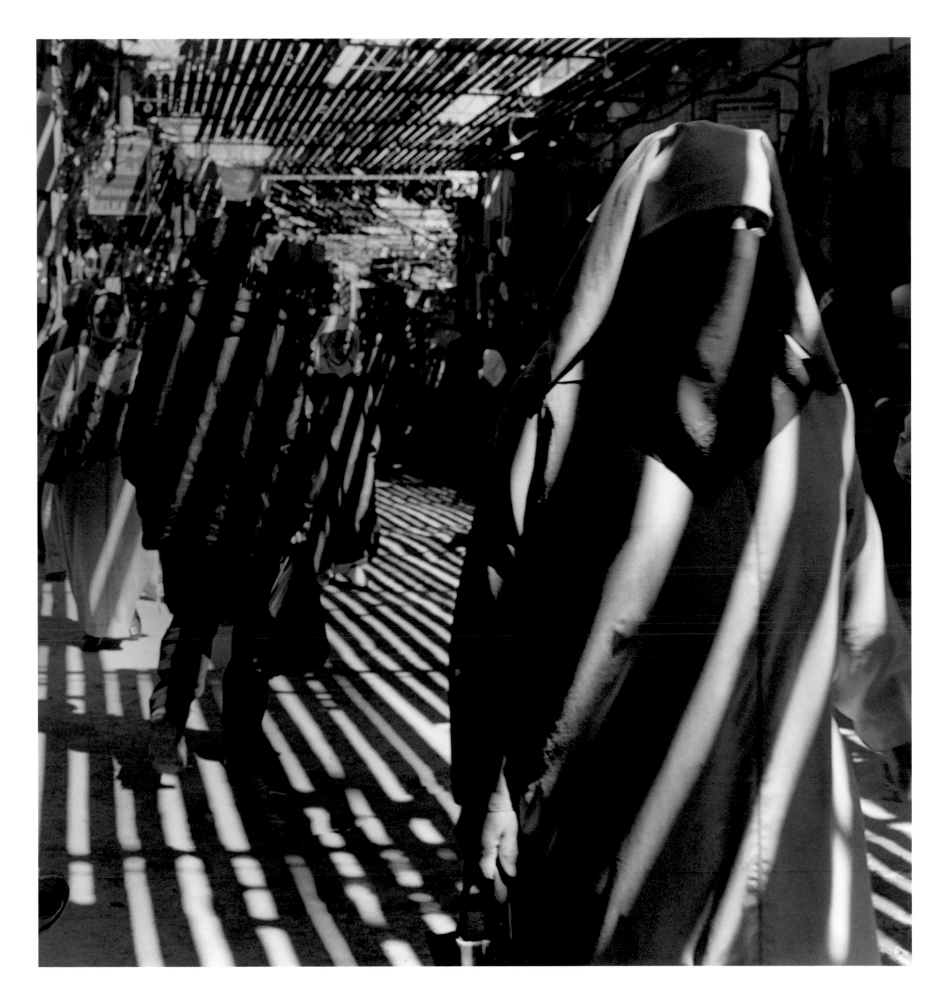

PLATE 35

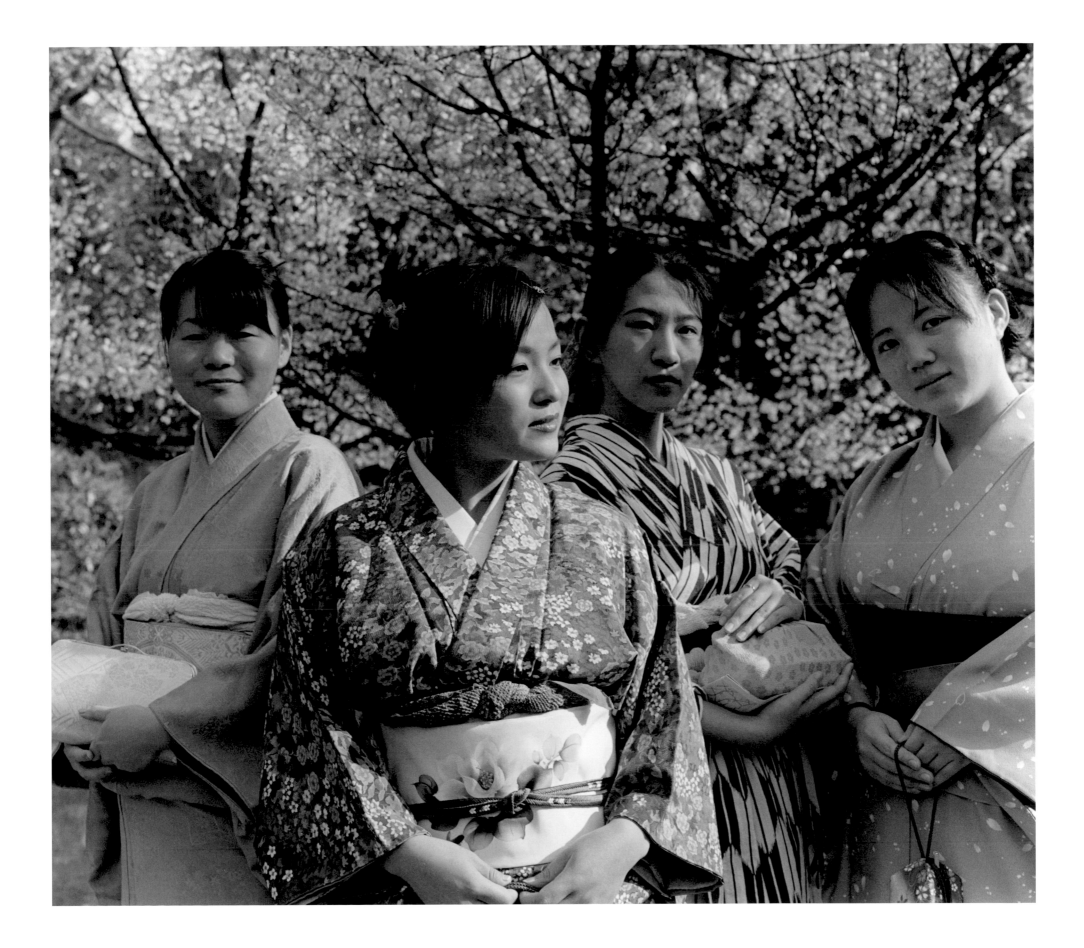

PLATE 36

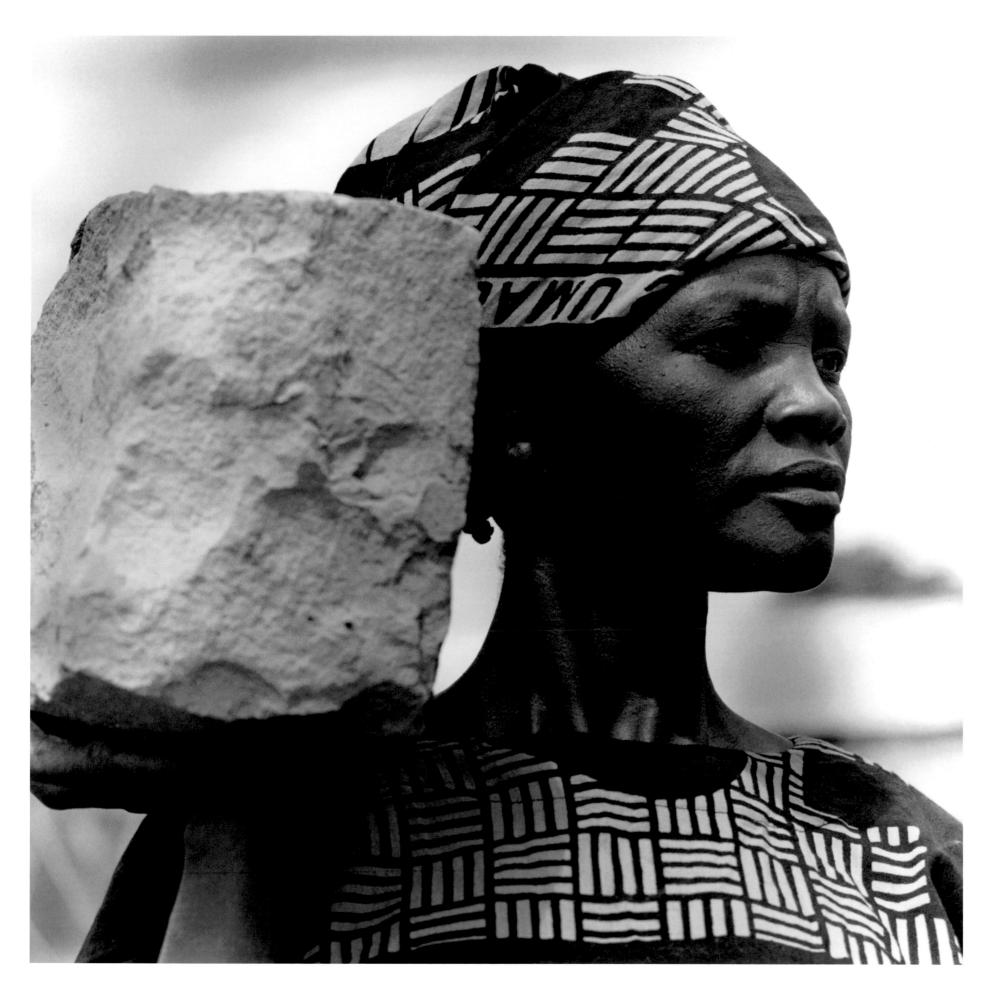

PLATE 37

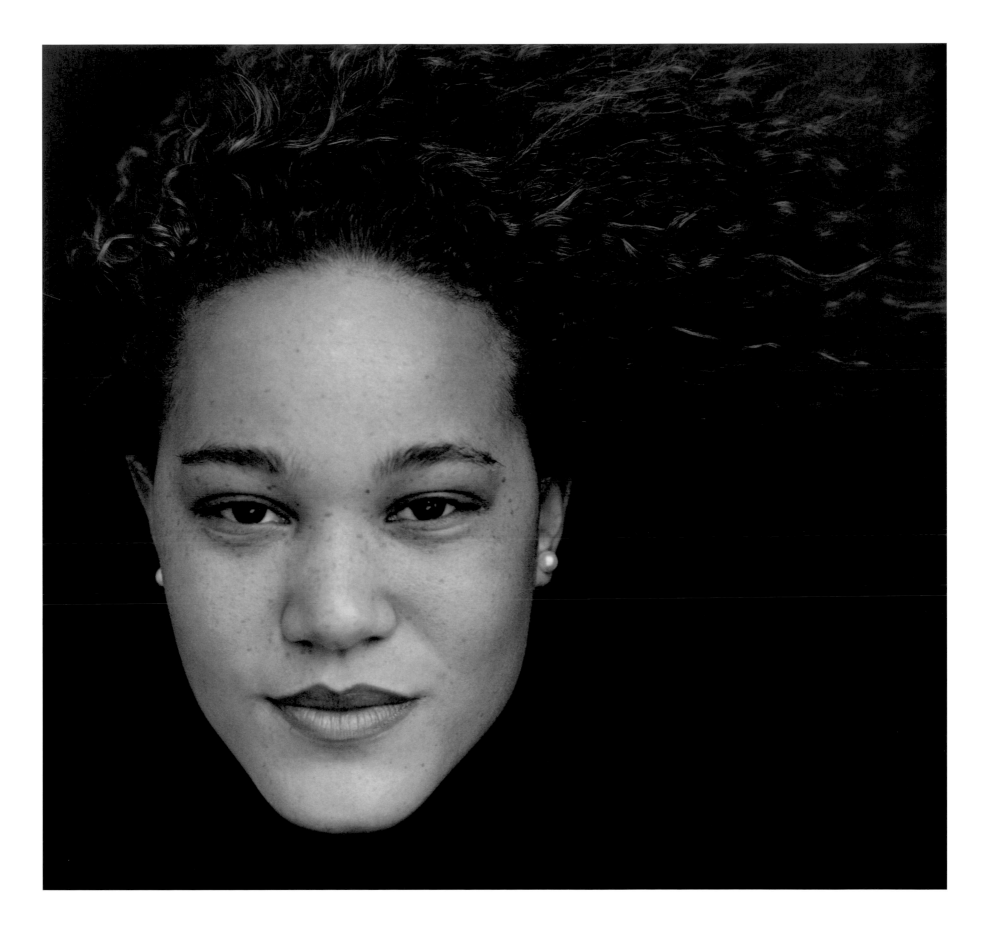

PLATE 38

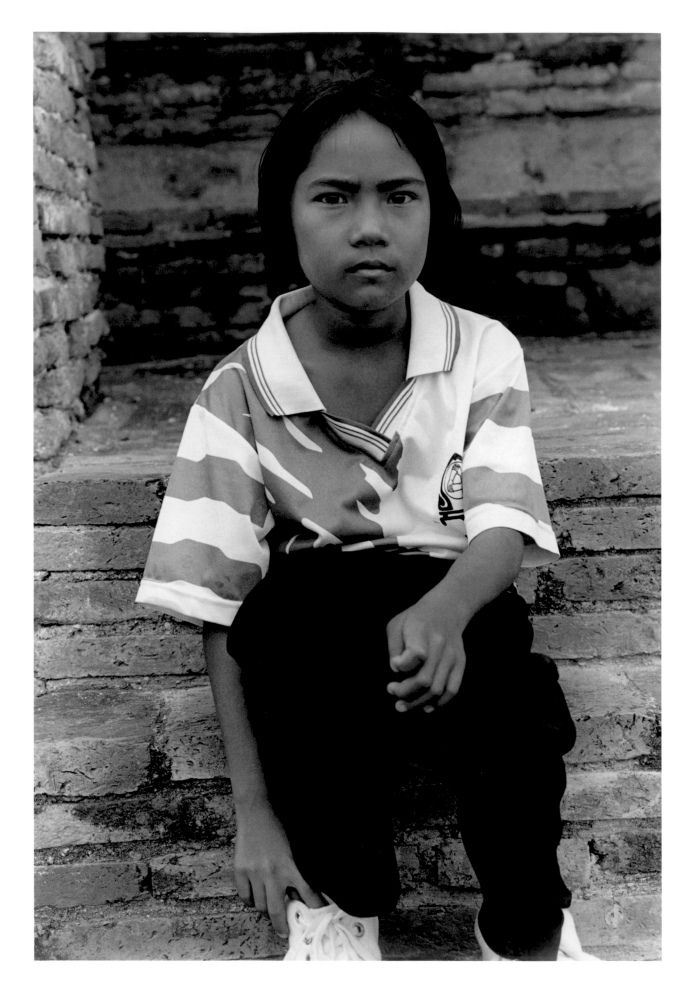

PLATE 39

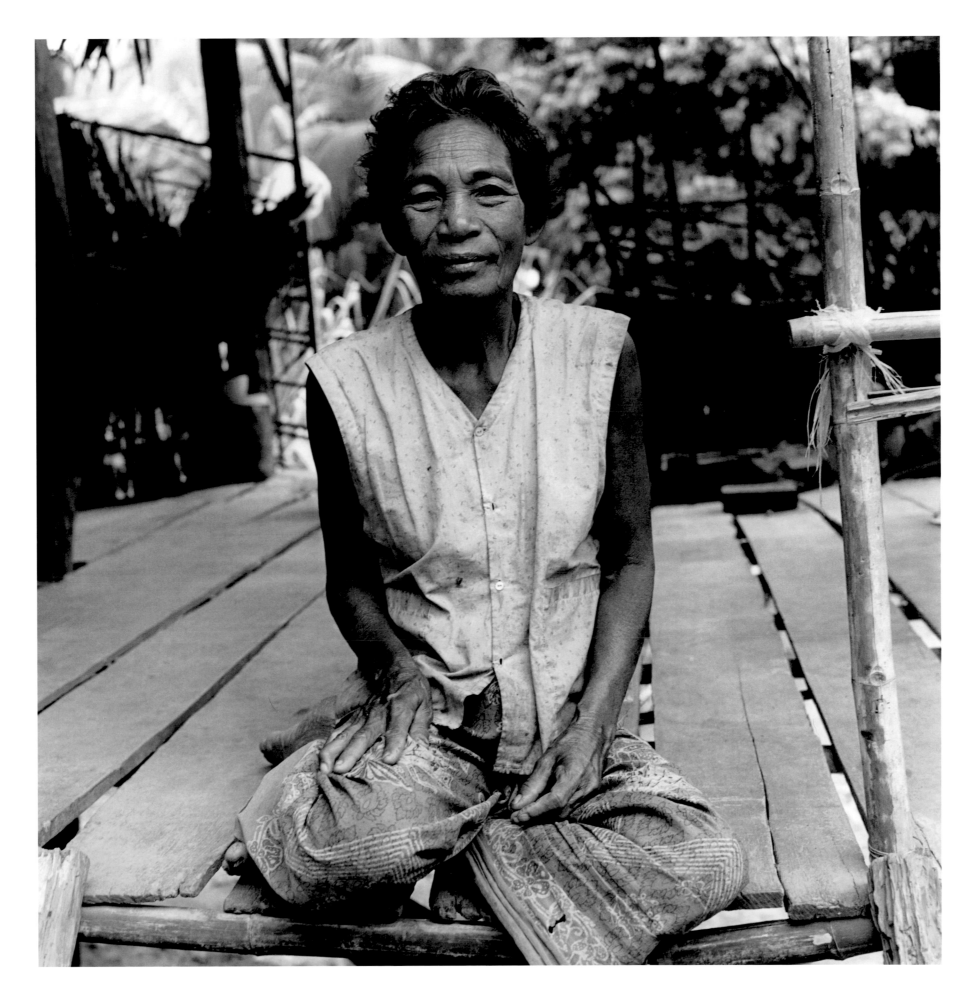

PLATE 40

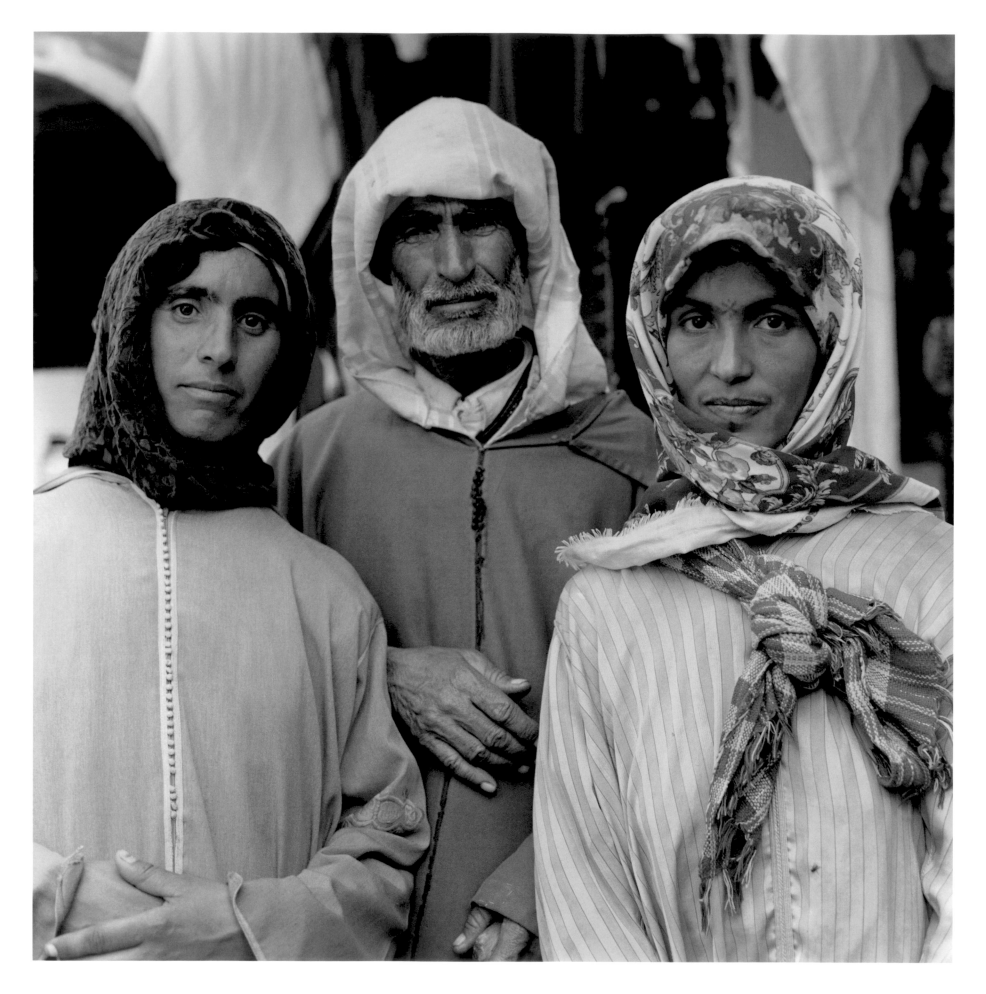

PLATE 41

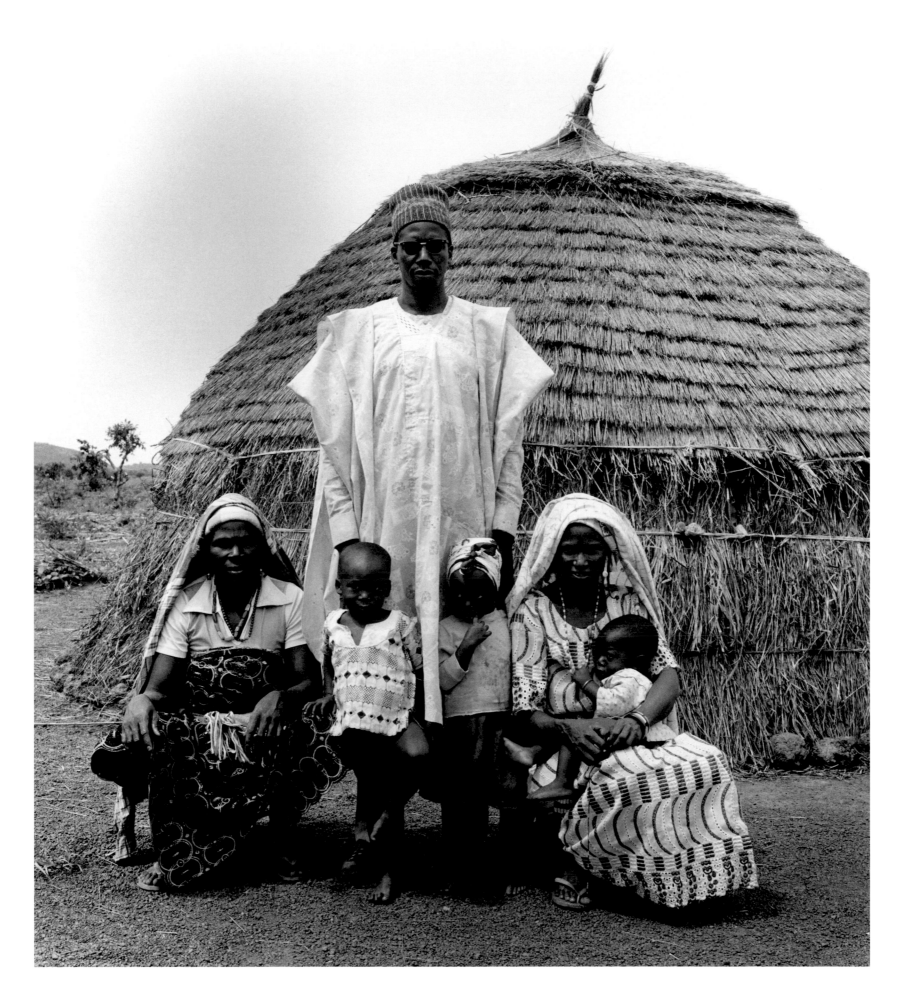

PLATE 42

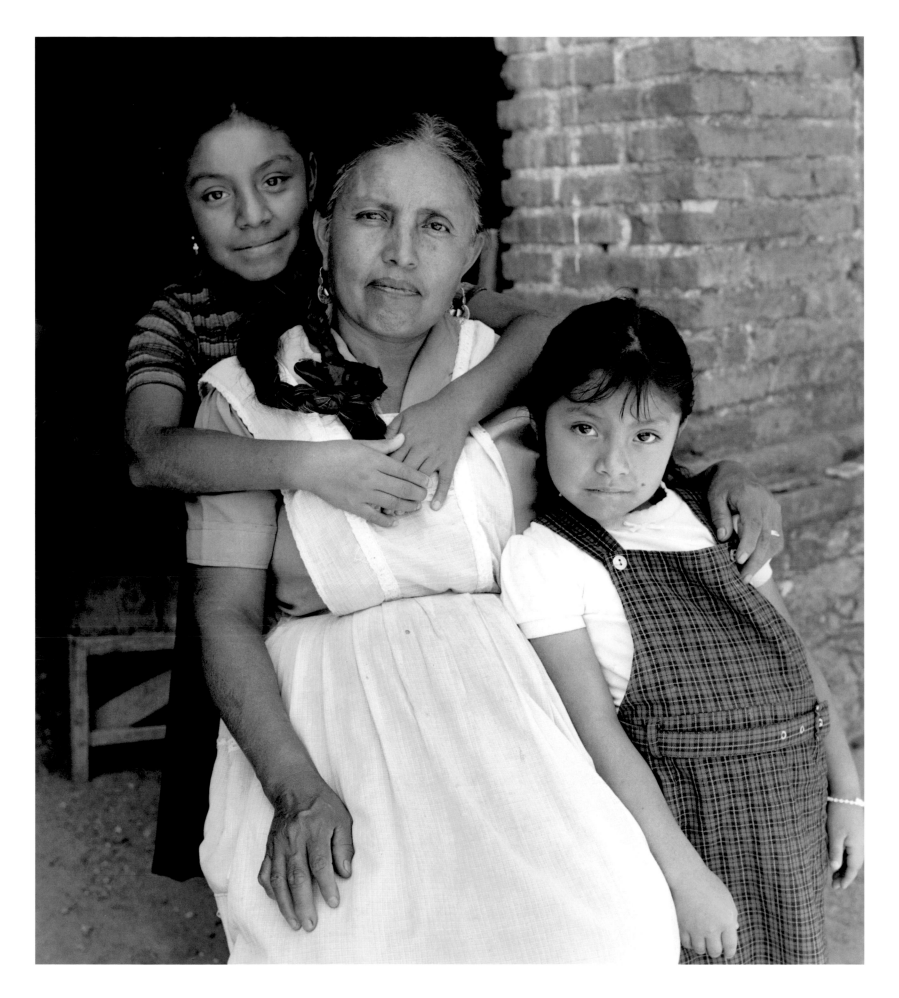

PLATE 43

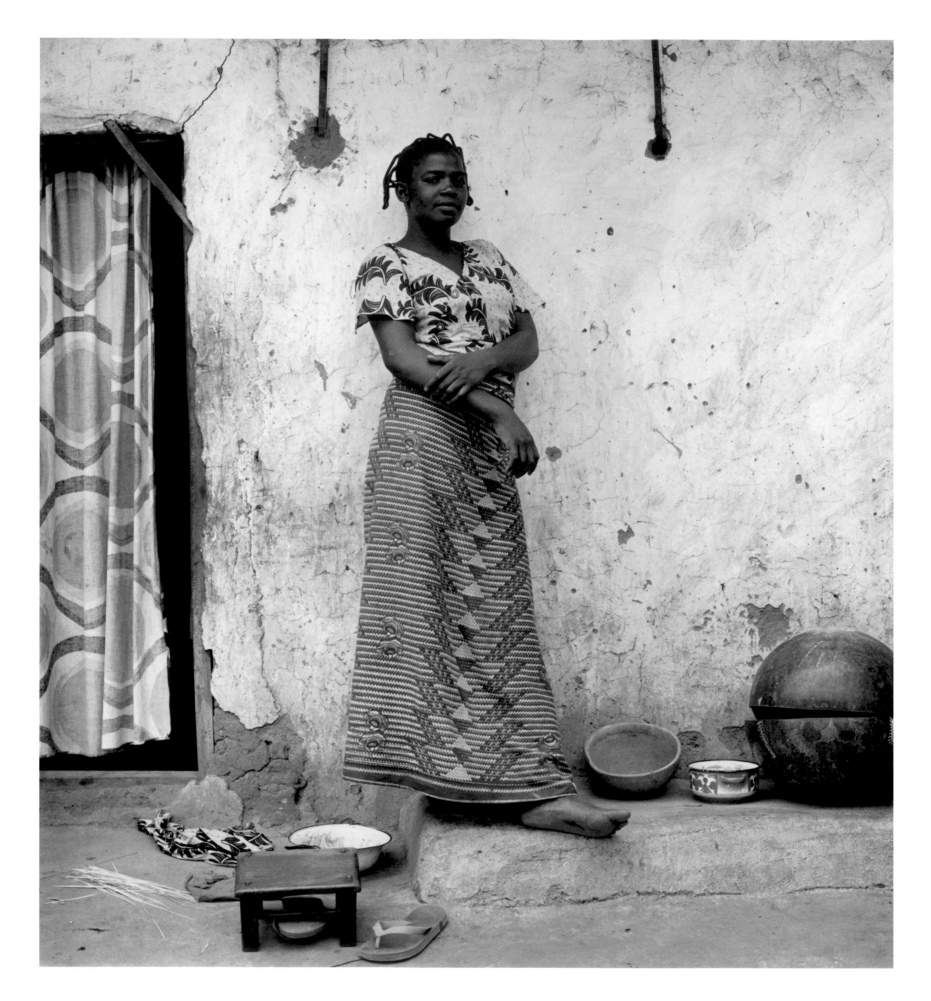

PLATE 44

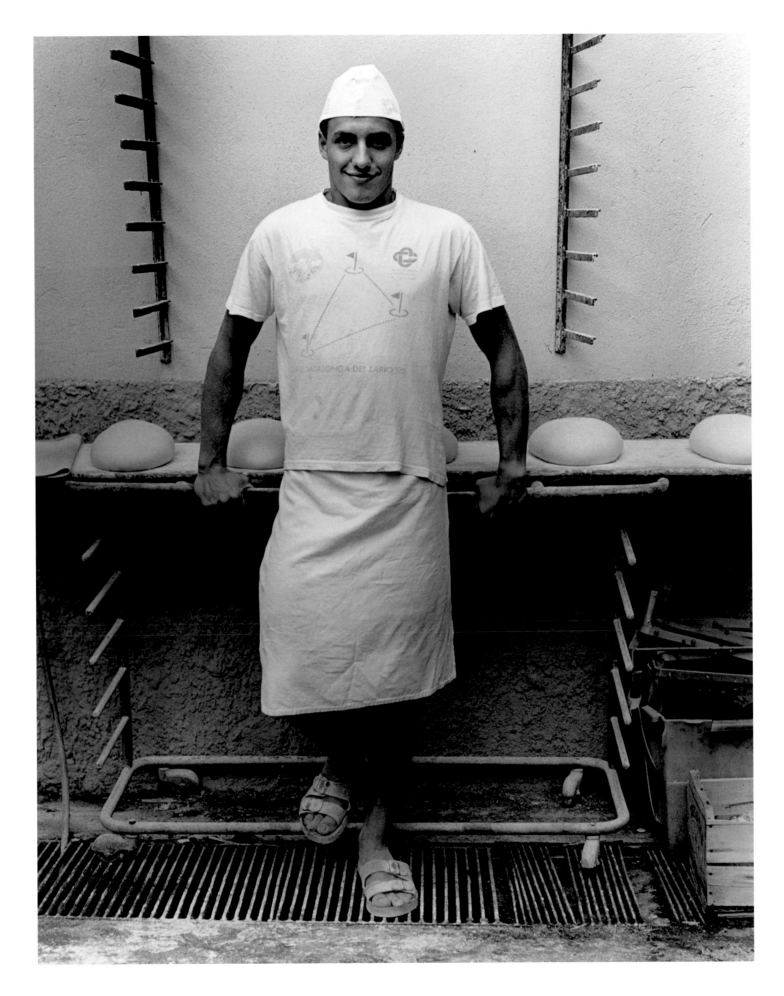

PLATE 45

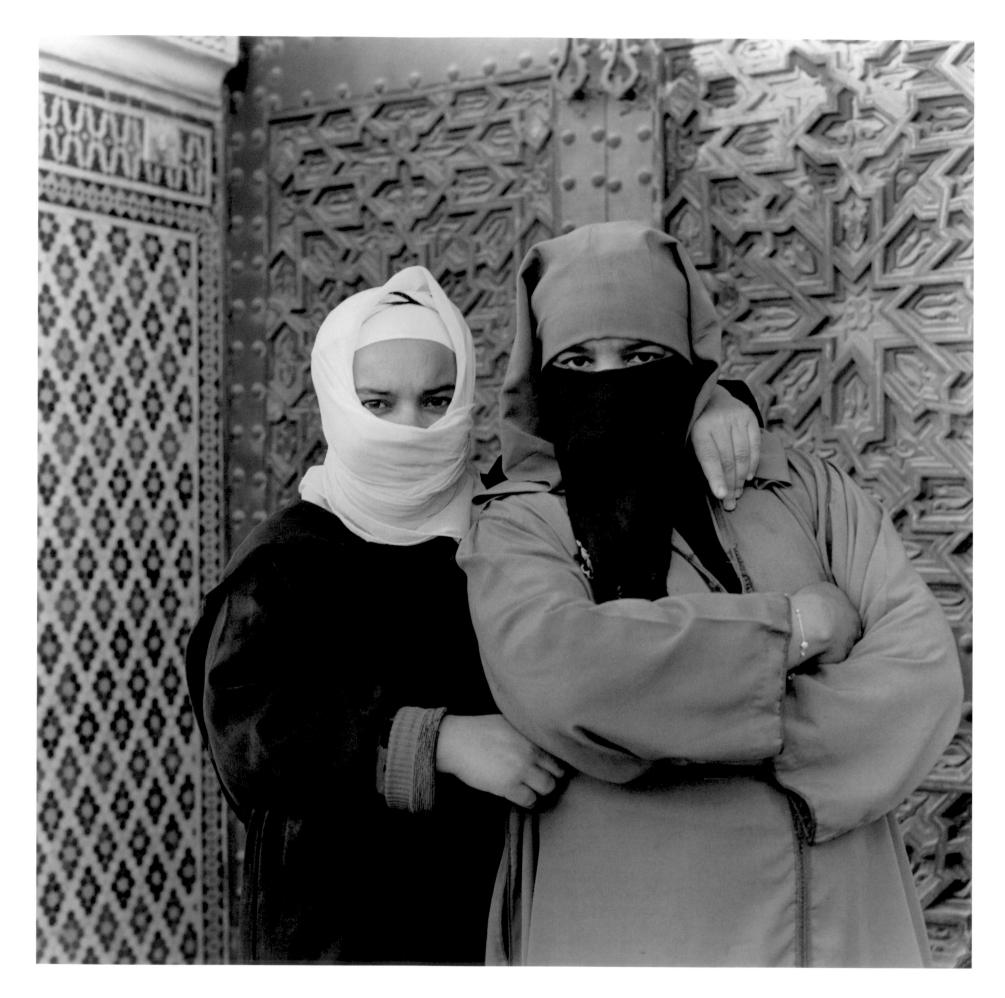

PLATE 46

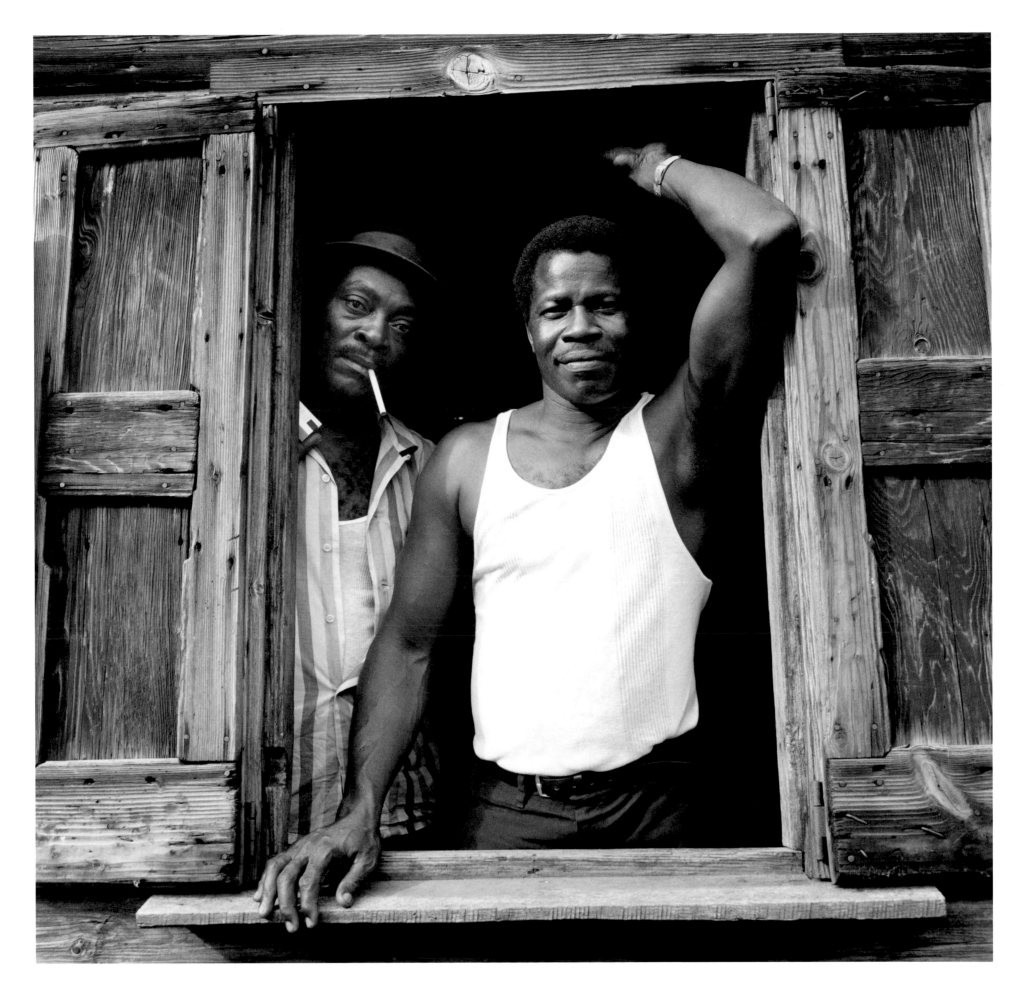

PLATE 47

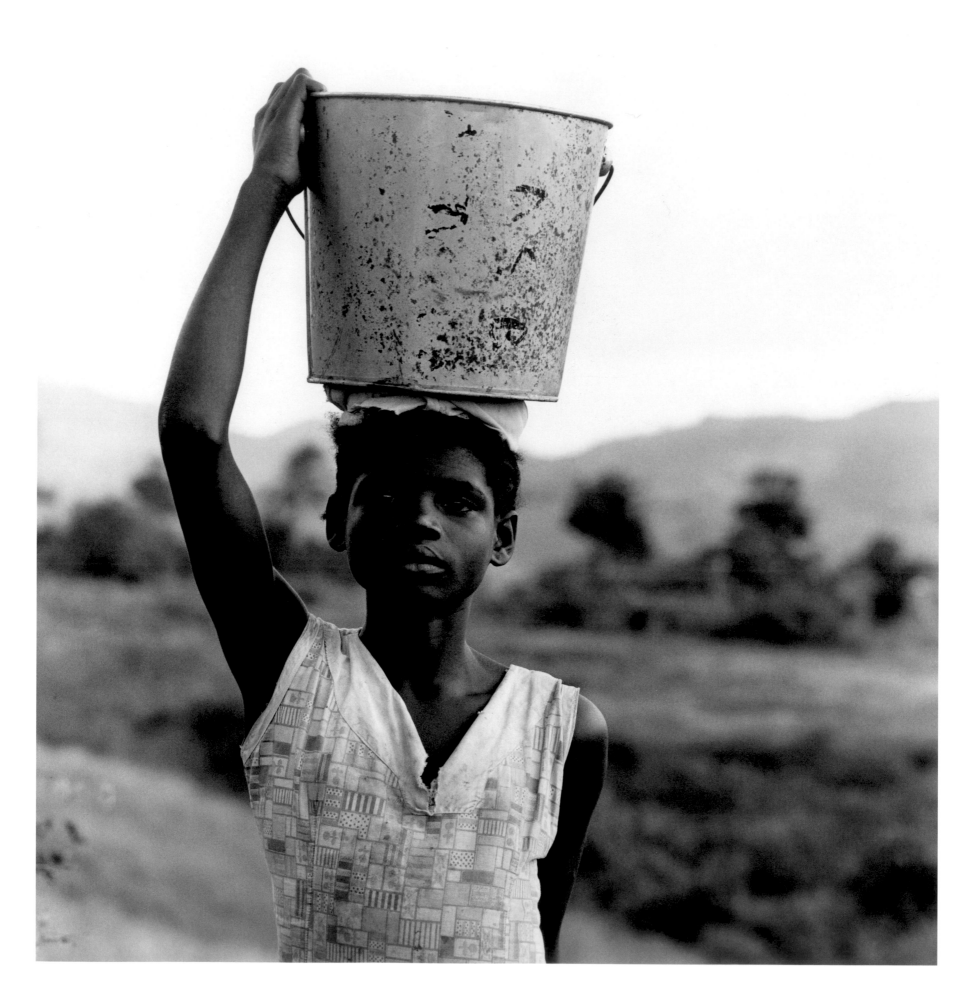

PLATE 48

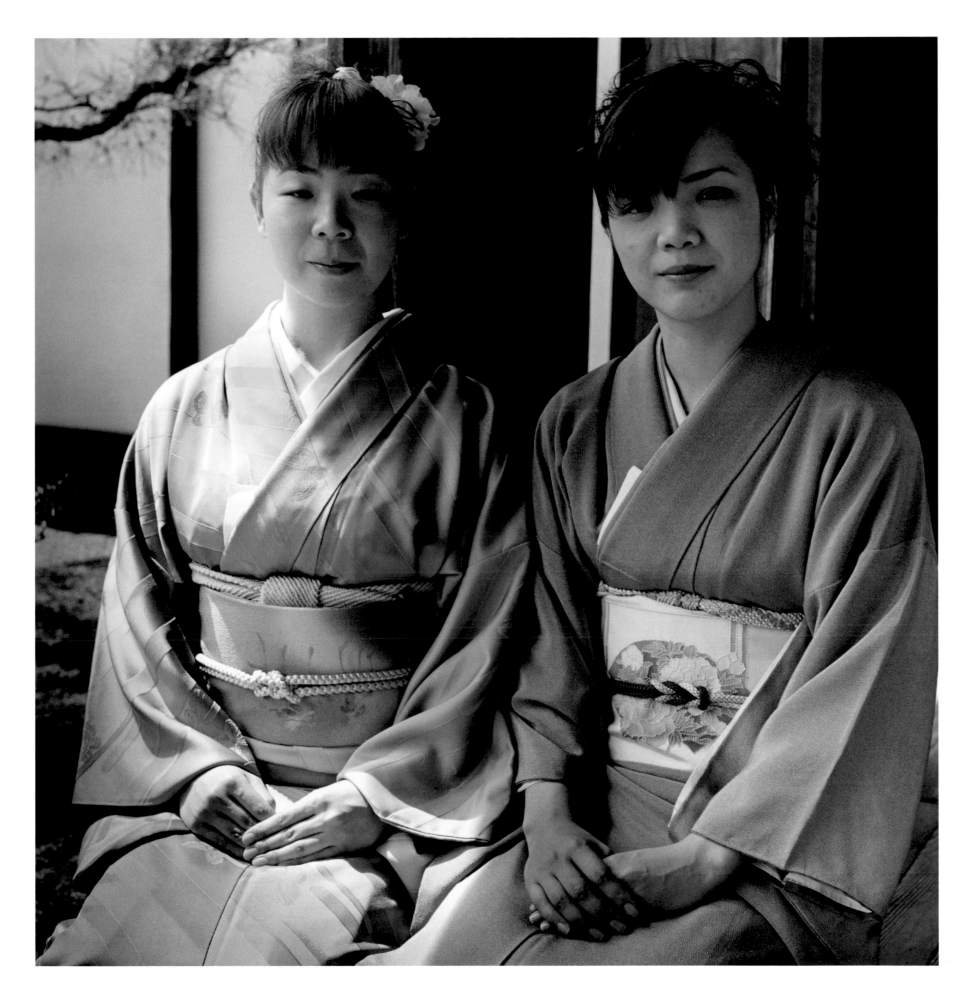

PLATE 49

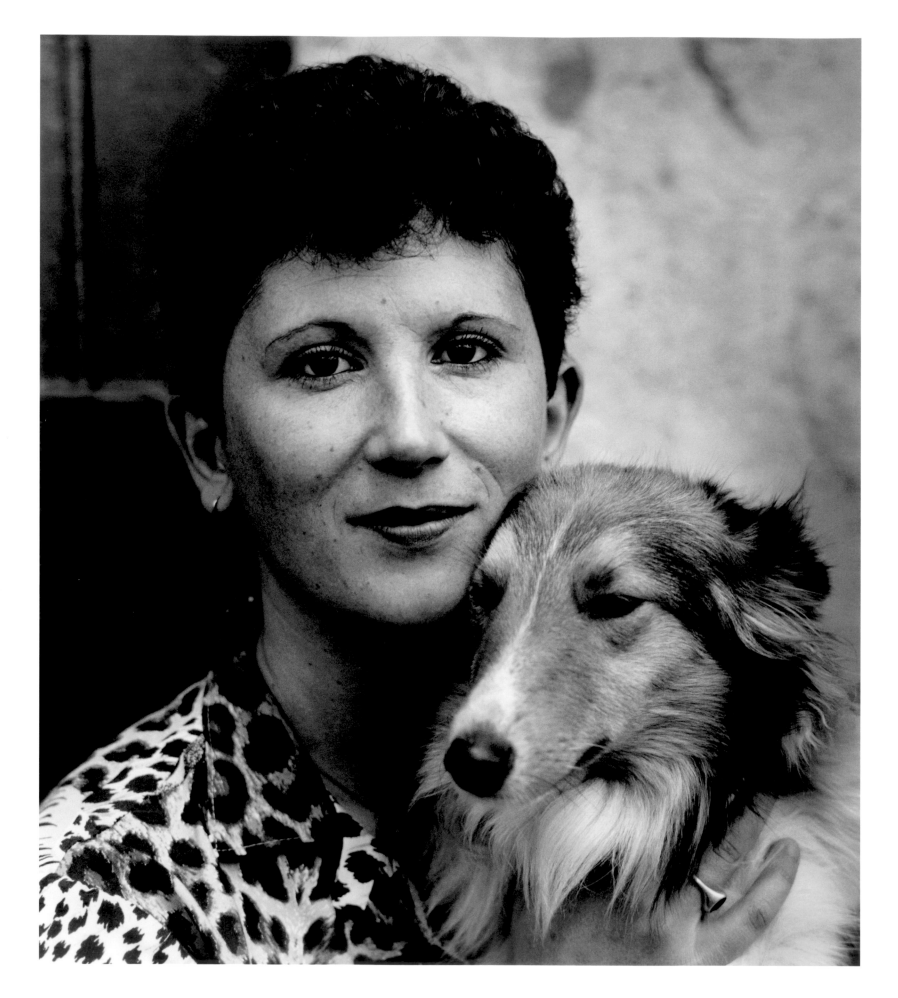

PLATE 50

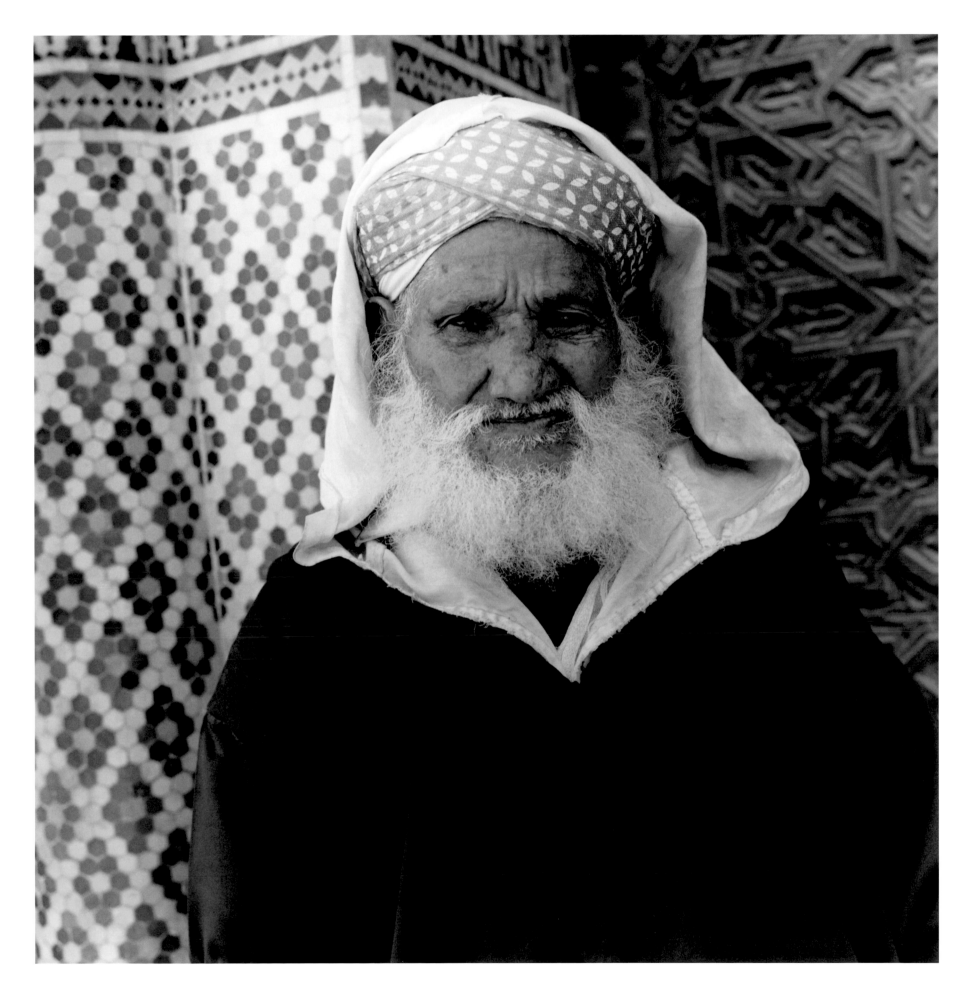

PLATE 51

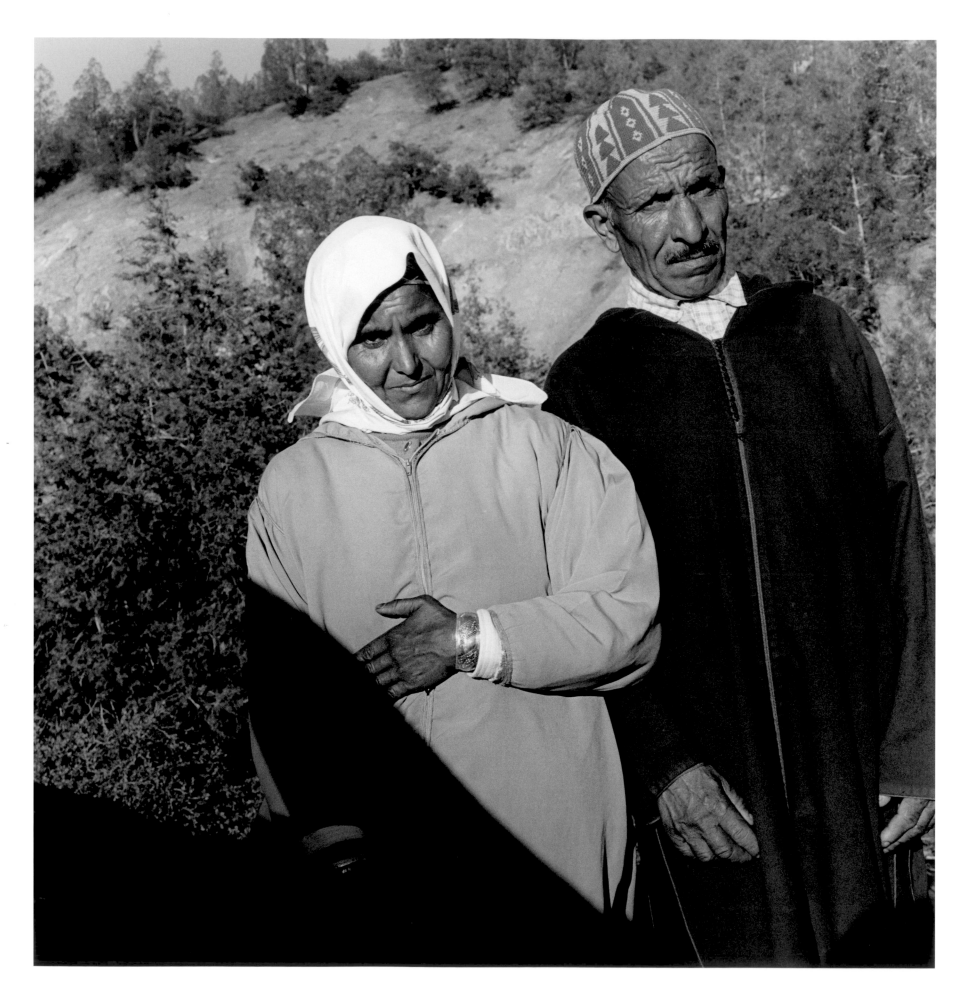

PLATE 52

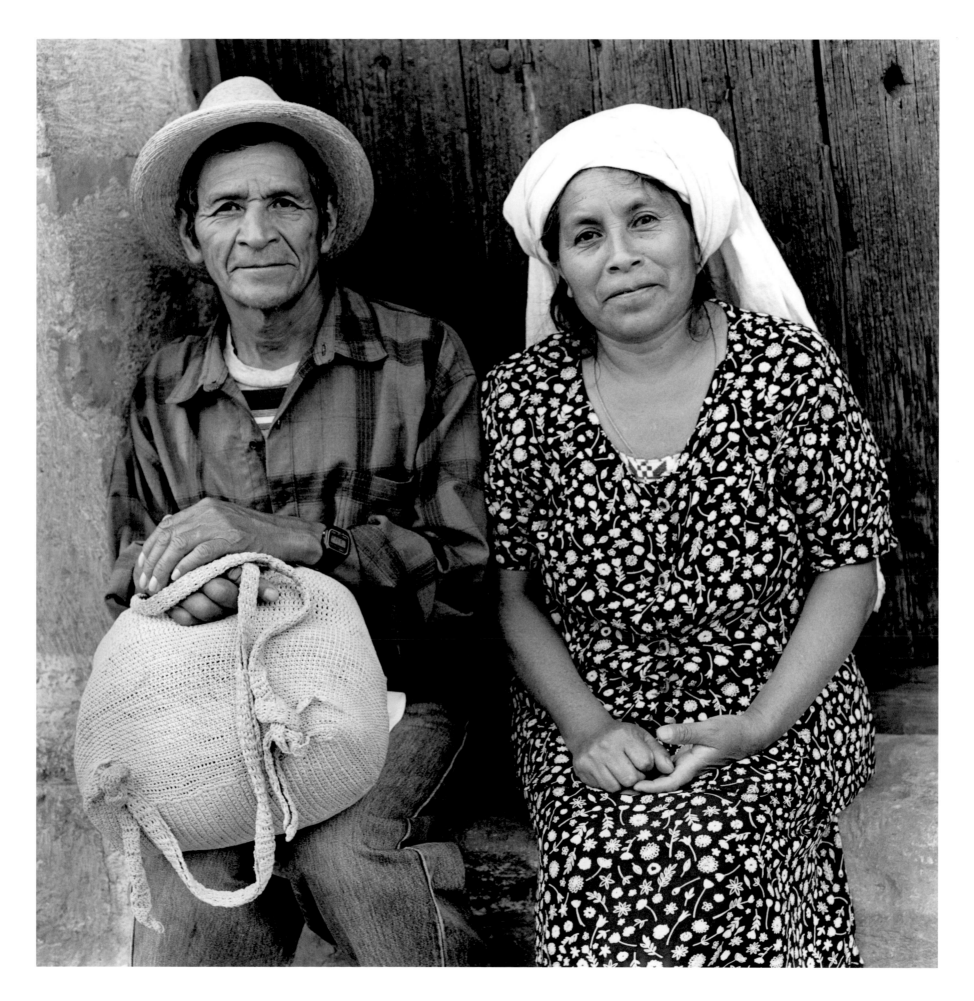

PLATE 53

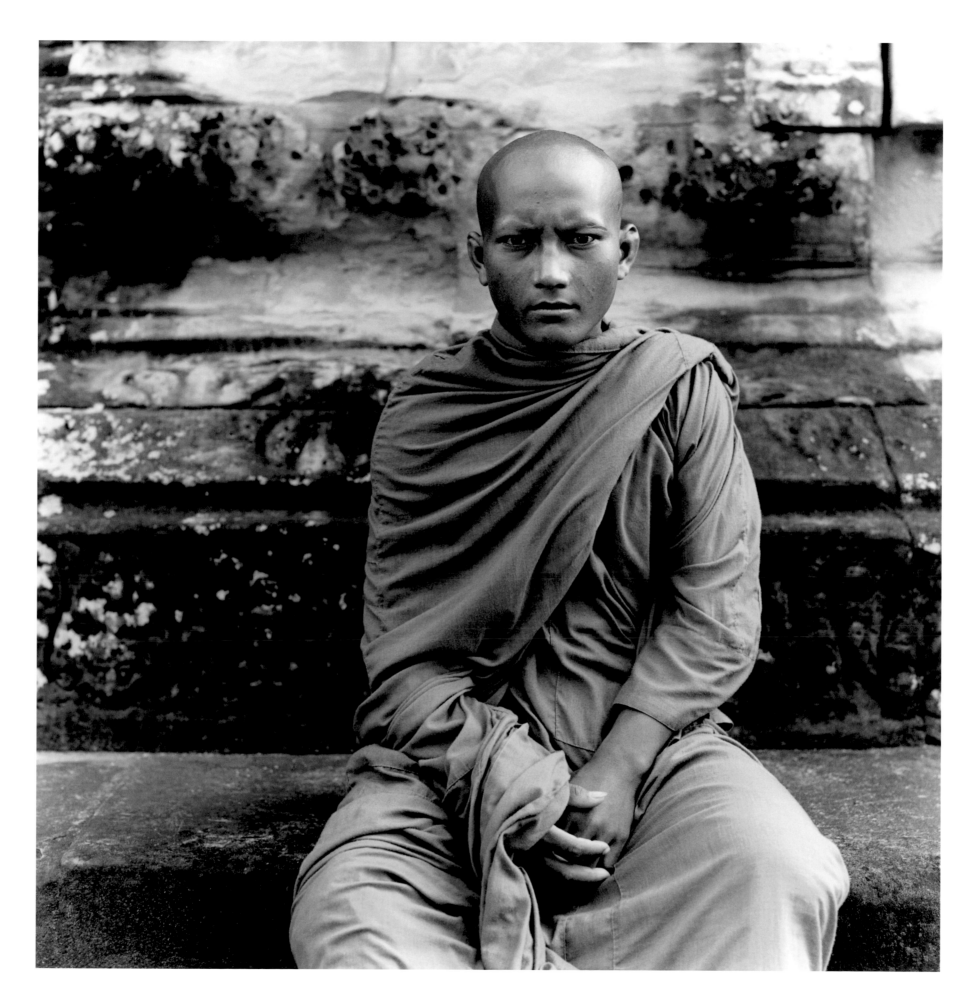

PLATE 54

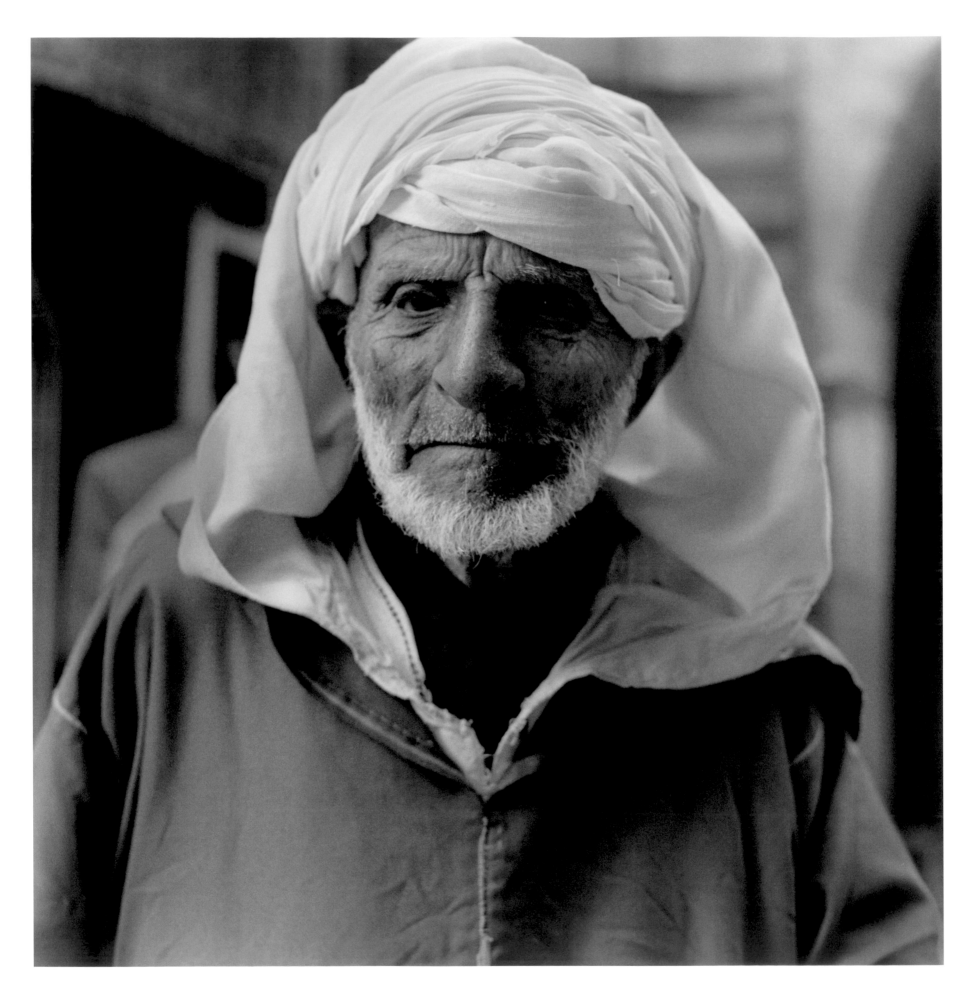

PLATE 55

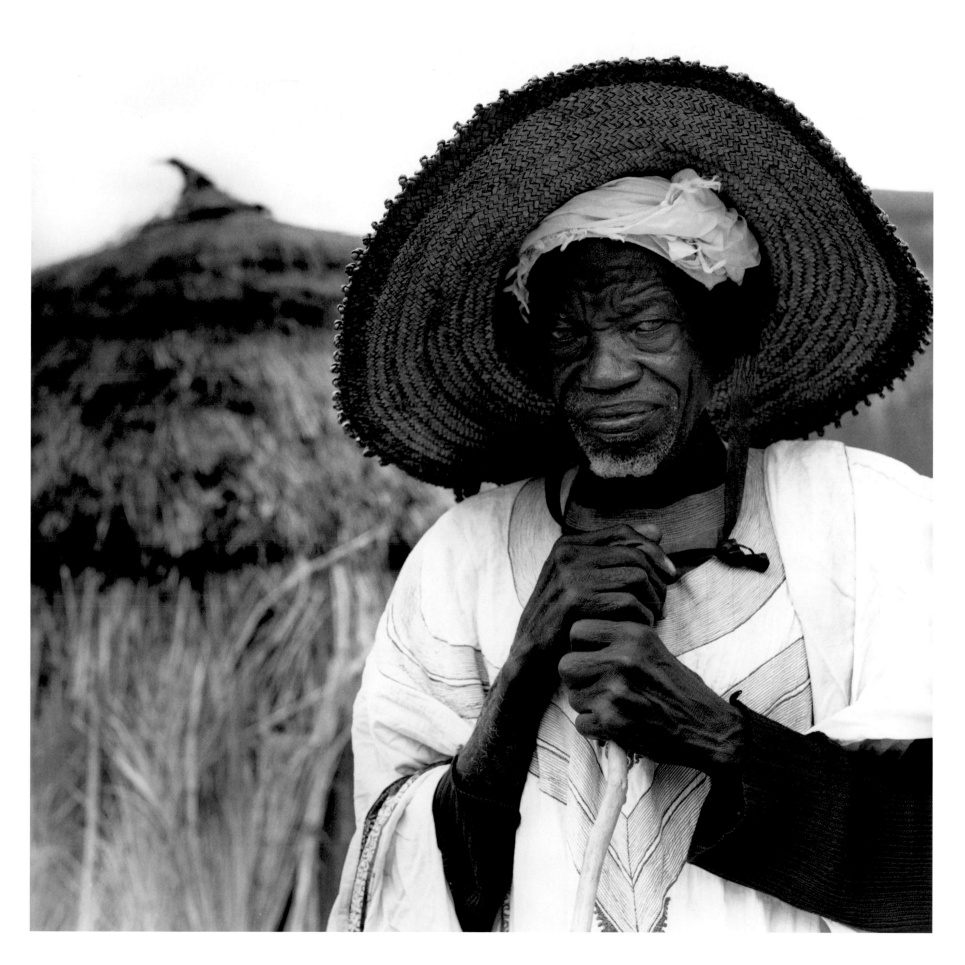

PLATE 56

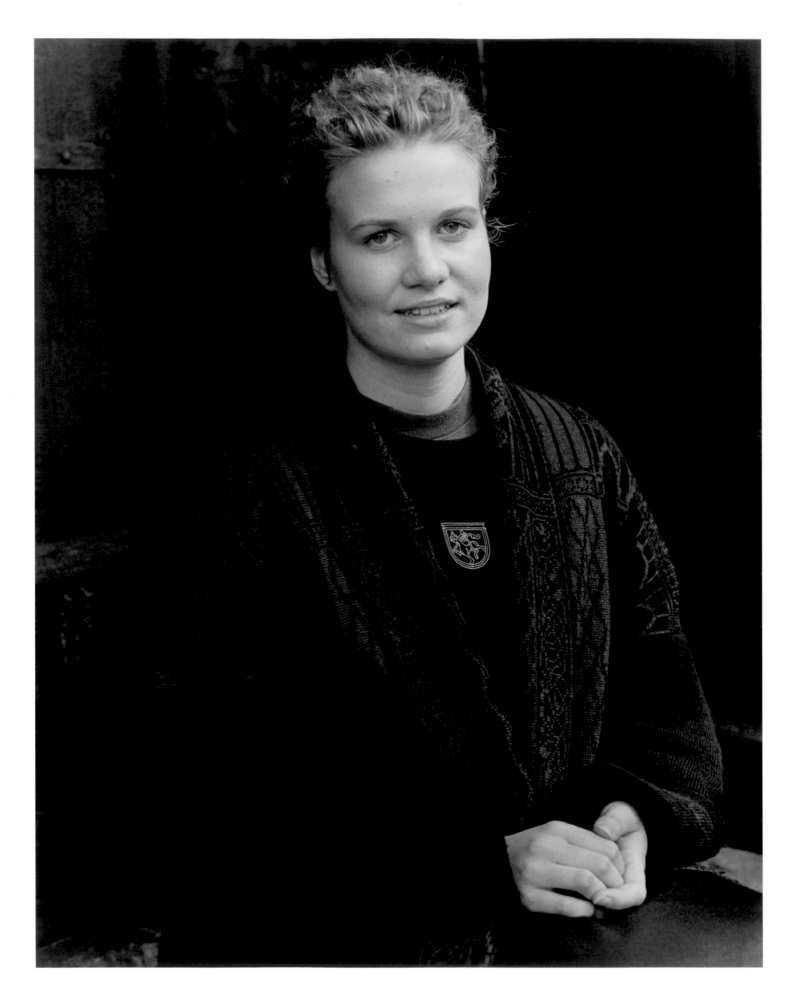

PLATE 57

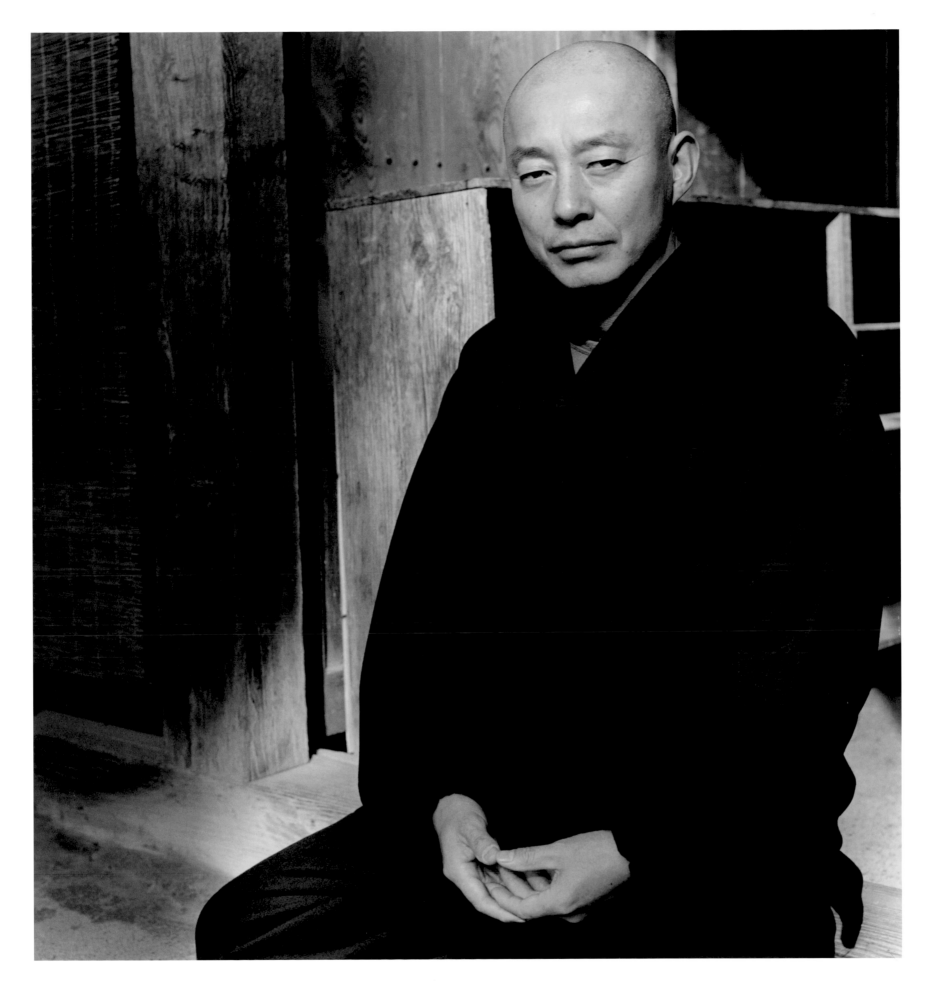

PLATE 58

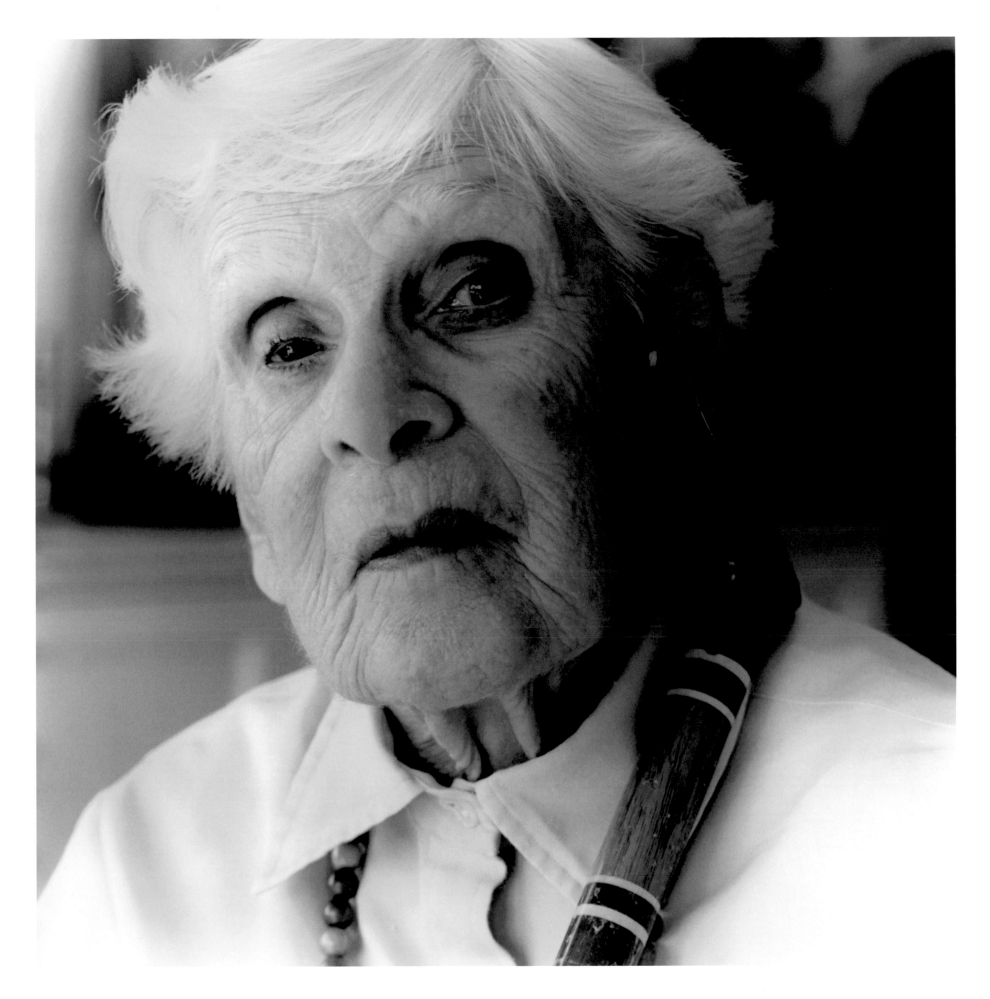

PLATE 59

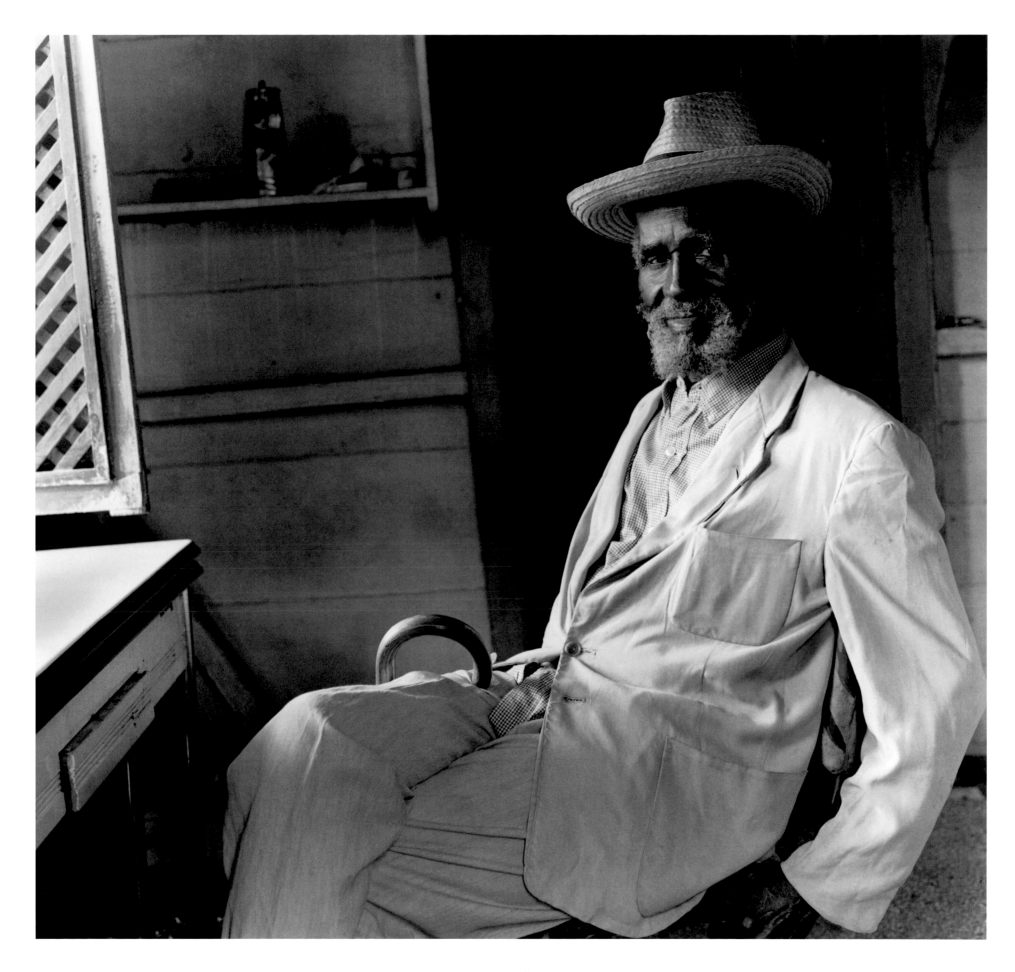

PLATE 60

PLATE 1. *Abashe and Grandchild, Abet, Nigeria, 1981*

This picture was taken next door to Ladi's house on the Abet plain. At first, I was not sure that the child was Abashe's grandson. I thought it might be his child. The Fulani are Muslim, and according to the Koran, men are allowed to have up to four wives. It was plausible that this could have been his child by a junior wife.

The leather amulet around the child's neck is to ward off evil.

PLATE 2. *Girl with Flowers, Cachoeira, Bahia, Brazil, 1986*

This little girl, like so many others in the countries I visited, seems to carry the weight of more years than her youth can bear. I am haunted by the sadness emanating from the faces of children who carry such burdens. I wonder about the façade that these children construct for the world. The face as façade—a mere edifice with a maze of tunnels and corridors running deep behind the surface.

PLATE 3. *Schoolboy Riding Goat, Norway, 2002*

I photographed him in the rain near one of the more isolated fjords. This young boy was on a school holiday from Bergen. It was extremely amusing to observe him trying to ride this goat as if it was a pony.

PLATE 4. *Roxbury Girl in Rubber Boots, Boston, Massachusetts, USA, 1965*

This is an early portrait taken while I was living in Boston, my first year after college. When I look at this portrait now, it seems like a precursor of the work that followed.

PLATE 5. *Xenia, San Francisco, California, USA, 1968*

Xenia's mother came to visit the Lawrence Ferlinghetti family house where I was living, in the lower apartment. I first saw Xenia as I looked out my window into the garden. She was collecting bugs in a jar filled with leaves. I grabbed my camera and went outside to talk to her. She agreed to pose, placing her jar on the fence post. Currently, thirty-six years later, she is a chemist with a corporation in Illinois and has a daughter who is the same age as she was in this picture.

PLATE 6. *Timothy, Marin County, California, USA, 1969*

Timothy is in his forties now, and lives in Linden, California. He rodeoed in college, and he is a bronc's rider. In 1991, he was in the Wild West Show at Disney in Paris. Presently, he judges rodeos. Though he only had a hat when he was young, he has the total package now.

This portrait expresses a very American kind of self-confidence. The attitude displayed here, while amusing in a youngster, is frequently

NOTES ON PHOTOGRAPHS

questioned by other countries outside the United States, especially when exhibited in the policies of American administrations.

PLATE 7. *Two Boys on Porch, Siem Riap, Cambodia, 2001*

These boys live in a village that is within the temple complex of Angkor Wat. Most everyone I came across in Thailand and Cambodia was more than willing to pose to have a picture taken. There was an openness there that we have not met, before or after. They never asked me for money, either, unlike in many other countries.

PLATE 8. *Friends with Water Bottle, Marrakesh, Morocco, 2002*

Her father was selling water and consented to the picture of his daughter and friend. Except for the Arabic script on the water bottle that indicates the geographic region—North Africa or the Middle East—these kids could be buddies anywhere in the world.

PLATE 9. *Young Boy, Potrero Hill Projects, San Francisco, California, USA, 1968*

During my first year in San Francisco, I lived on Potrero Hill. I started photographing in the Potrero Hill projects on the east side of the hill. This portrait was taken there.

PLATE 10. *Schoolboy with Backpack, Siem Riap, Cambodia, 2001*

This young boy was clearly on his way to accomplish something important in life. His white shirt was pristine, and he had an energy and spirit that were undeniable.

PLATE 11. *Carrying Home Mangoes, Antigua, West Indies, 1970*

I was driving from the country to town when I spied this group in the rearview mirror. I stopped the car, pulled out the camera, and ran back toward the kids and asked them to pose for me. They arranged themselves this way.

PLATE 12. *Mother and Child, Marrakesh, Morocco, 2002*

We were heading back to our hotel after a long morning photographing in the souk. I saw this woman with her child plodding along in the blistering sun and wearing a look of distress so intense that I did not think I would have the courage to ask her to pose. My husband, Tony, remarked that if I did not ask, I would go without and warned me about my regret afterward. I mustered the courage to ask her in French, and took this picture.

Afterward, she told us that she was coming from the morgue; her husband had just died. I felt terrible. (W. Eugene Smith describes his sense of having committed a possible impropriety when he stopped to ask if he could photograph in the home of a family gathered around the deathbed of their father.)

She had been willing to pose with her daughter under very stressful circumstances, and she was grateful for the cash that we gave her.

PLATE 13. *Seralyn and Pauline, Taos Pueblo, Taos, New Mexico, 2003*

Seralyn and Pauline are a mother and daughter whom we met on the Taos Pueblo. Seralyn owns a beautiful shop just across the creek on the Pueblo grounds. Their Pueblo names are Gathering Flowers and Mountain Cliff Flower, respectively. Note the Statue of Liberty holding the American flag pictured on Pauline's T-shirt! To me, this seemed so ironic!

PLATE 14. *Sally, Antigua, West Indies, 1975*

Sally is my daughter's cousin. She lives in Antigua and has three children now. Her dad is Antiguan, and her mom is English. In 1975, at the time of this photograph, she was eleven years old and had the fullest head of hair I had ever seen on any child.

PLATE 15. *Girl with Carved Birds, Oaxaca Zocolo, 2001*

She was selling her small carvings in the main square in Oaxaca. Her eyes were dark pools of doubt and insecurity. We spent quite a bit of time with her. I had to drag my husband away—he wanted to take her home with us and send her to school.

PLATE 16. *Marquesan Island Girl, Papeete, Tahiti, French Polynesia, 2002*

She was sitting near her father as he was carving in wood at the annual Marquesan arts and crafts fair in Papeete, Tahiti. In her silence, there was fear and disappointment. Arbus has said, "A photograph is a secret about a secret; the more it tells you, the less you know." I definitely feel that from this portrait.

PLATE 17. *Beatrice, Cachoeira, Bahia, Brazil, 1986*

Beatrice was one of the youngest members of a sisterhood, the Nossa Señora Da Boa Morte. This group dates back to slave times when it was formed to buy the freedom of women slaves. The group is active to this day; every year in August the group celebrates with a three-day festival of feasts, parades, and dancing.

PLATE 18. *Caroline Minet, Arles, France, 1996*

Caroline was born in nearby Nimes. She was participating in the Camarguais festival in Arles, which celebrates the cowboy culture of

Languedoc in this southern region of France. Caroline was striking even in the huge crowd, and I asked her if she would model for my UC Santa Cruz students. She agreed and came to our hotel the next day. The jeweled cross, painted fan, antique shawl, and traditional hairdo resonate with the ambiance of the Mediterranean, southern France, Spain, and Italy all in the mix.

PLATE 19. *Mohi Santos, Marquesan Artist, Moorea, French Polynesia, 2002*

We bought a stone sculpture from Mohi. He was like a sculpture himself! He was from the Marquesas and was visiting Moorea.

PLATE 20. *Poerava, Tahiti, Polynesia, 2002*

I know that all photographers live with images in their mind's eye that were never recorded on film. There is always the proverbial missed opportunity. When I saw Poerava first, it was in my mind's eye—literally. We were traveling in a jeep down a country road in Tahiti when I shouted to stop the car. I knew I had seen something striking about one quarter of a mile back, on the side of the road and down an incline near a creek.

We backed up the car, until I saw her for real. I took the camera and walked down the hill and asked the two women in French if I could photograph them. I was really interested in a portrait of Poerava alone, but, for discretion's sake, I first took pictures of the two together. And then, I did this one of Poerava.

PLATE 21. *Bolans Village Woman, Antigua, West Indies, 1967*

This is one of the images that Ruth Bernhard always loved. She taught me to dodge (hold back the light) on this print, revealing the hair above the bandana. It is one of the earliest close-up portraits that I did in Antigua.

PLATE 22. *Romanian Gypsy, Rendek Farm, Kerekegyhaza, Hungary, 2002*

When I saw this handsome man, he was driving the pigs from one trough to another. He stopped his work to clean up and pose for me on the porch of the Rendeks' house. The hanging red peppers remind us in the New World of Mexico, and he does, in fact, look Mexican. However, in Europe the peppers are associated with sweet paprika and the country, Hungary, from whence they come.

PLATE 23. *Workers in Taller, Paper Factory, San Augustin Etla, Oaxaca, Mexico, 2001*

We traveled for about forty minutes out of Oaxaca city to this *taller* where paper is made from local fibers. It was founded by a group of Oaxacan artists trying to revive the art of papermaking. These two

workers were setting the paper pulp in frames. They seemed to be good buddies as well.

PLATE 24. *Ladi, Fulani Girl, Nigeria, 1981*

I spent several weeks on the *ruga* with Ladi and her grandmother, Juma. I took this picture early one morning as I came out from the small grass house where they lived. I did so many things with Ladi. She took me dancing at night on the *ruga*, and to the produce market in town. One year, during my third trip back to Nigeria, we took the ILCA Land Rover and with a driver, Ladi, Juma, and I traveled for a whole day to the other side of Jos to find Ladi's parents and bring them provisions. Ladi's father was so grateful that he tried to pay me many Nigerian *naira* to thank me. I had to struggle with him to make him take the money back. After getting to know Ladi so well, it was great to meet her parents and siblings.

PLATE 25. *Archana from Bangalore, India (taken in Palo Alto, California), 2001*

I met Archana at a Shadihika fund-raising event in Palo Alto. Shadihika supports needy women's and children's grassroots organizations in India. Archana was dancing in the southern Indian style for the event. She agreed to model for me. She is a design engineer for Hewlett-Packard in Palo Alto; dancing is her hobby.

I made this portrait in my living room. Sometimes there are moments like this when the subject seems more themselves without direct eye contact. In this portrait, the eyes averted say more about that moment.

At the end of her life, Diane Arbus, the photographer, said that she saw a subject more clearly if they are not "watching me watching them."

PLATE 26. *Women with Henna Hands, Marrakesh Souk, Morocco, 2002*

This woman was selling fabric in a flea market in the inner souk. It was a small separate area with only women gathered in it. All my requests to photograph were refused until I came across these women deep in conversation. One was "watching me watching them"—two voyeurs, one with camera.

Her hand is decorated with henna after an ancient art called Mehndi. It was first used in Egypt and is used presently in India, the Middle East, North Africa, and Asia. In Morocco they say it has healing properties and wards off evil.

PLATE 27. *Sugar Cane Worker, Antigua, West Indies, 1970*

In the winter of 1970 I went to Antigua specifically to photograph the cutting of the sugar cane. It was one of the last cane harvests in Antigua before they abandoned sugar altogether. This worker was loading canes

in the fields, and he is sitting on an iron cart that was used to transport the cane to the factory.

PLATE 28. *Rower, Countryside, Tahiti, French Polynesia, 2002*

Even though the wrap on his head could signal Islamic militancy to a Westerner in the post-9/11 era, it was only protection against the unrelenting sun. He was on his way to row his kayak, practicing for an interisland competition.

PLATE 29. *Doña Margarita, Teotitlan del Valle, Mexico, 2001*

Doña Margarita and her husband, Matteo, have been the honored keepers of an unusual crucifix that, it is said, dates back to the seventeenth century. Their home in Teotitlan del Valle, Oaxaca, is a compound that includes a small chapel that houses the wooden life-size black Christ. There are very few black Christs in Mexico. Their family has been the guardians for generations.

Doña Margarita, however, was busy offering us fresh eggs and local chocolate for making mole. Her striking face inspired this portrait in the sunlight on her patio. She reminded my husband of his grandmother, Molanita, who was a Black Foot Indian.

PLATE 30. *Blind Woman, Oaxaca Cathedral, Mexico, 2001*

I hesitated to take this picture because she was blind and could not see me gesture toward the camera for her approval. I don't speak Spanish, so it was not possible to ask permission. Since I never make a portrait without the full cooperation of my subject, I almost decided against making this picture. But something compelled me toward her. Her eyes were watching God. I snapped this image and filled her cup with pesos.

It was strange photographing a blind person—like I was transgressing. The gaze of my eye and my camera would not be echoed by the response of the subject. It felt unequal, almost unethical. The camera unrelentingly scrutinizes the unconscious subject; with communion between artist and subject there is little doubt about the watcher and the watched. Am I looking for clarity or toying with mystery? An image of a person who has been caught unaware on film gives at least the illusion of mystery—the illusion of a secret withheld.

PLATE 31. *Igako Asada, Owner, Asadaya Ryokan, Japan, 2003*

When I traveled to Japan, I decided that I did not want to spend even one night in a Western-style hotel. I used the Japan Travel Bureau in San Francisco to plan our journey, asking them to book us into traditional

inns where we could sleep on tatami mats and futons, bathe in the traditional wooden tubs, and eat Japanese-style meals served on a low table in our room.

That is how my husband and I found one of the oldest ryokans in Japan—the Asadaya Ryokan in Kanazawa on the Sea of Japan. The inn is still run by the same family that has run it for over eight hundred years—a samurai family well known in the area as having been messengers for the emperors.

The owner greeted us on our first day and offered to assist us in planning our visit around Kanazawa. Since our intended purpose was photographing, I asked him if, by any chance, he had a grandmother who was alive. I was delighted to hear that she lived next door. The next morning Igako arrived in a very beautiful kimono. The obi had an emerald embedded in the fabric. I located a room in her inn with soft light and a hint of the old architecture. Igako settled on her knees. In a flash I saw centuries of Japanese culture in one image.

PLATE 32. *Woman Selling Candles, Angkor Wat, Cambodia, 2001*

When we were entering the temple complex, we passed her. I considered waiting to photograph her until we were on the way out. Tony suggested seizing the moment immediately, and so I did. I set up the tripod right in front of her and asked for permission by pointing to my camera. She nodded, and I took a series of images. Each was a very long exposure because of the low light—but happily, she was so fascinated by me that she sat transfixed.

PLATE 33. *Aunt Justica, Domok Farm, Kerekegyhaza, Hungary, 2002*

Aunt Justica and her husband were really too old to be responsible for maintaining and operating a pig farm; they were just barely surviving there. They invited us into their house for watermelon. The day was extremely humid and hot, and we were happy for the melon. If it had not been too dark at the kitchen table, I would have photographed Aunt Justica as she cut up the melon. Alas, there was not enough light, so she and I made the portrait outside where she stacked corncobs for the pigs.

PLATE 34. *Vivian, Taos Pueblo, Taos, New Mexico, USA, 2003*

There was an Australian photographer taking a picture of Vivian, so it was easy for me to ask for another picture. She was very old and talkative, but it was difficult to follow her conversation. She also said she had a Pueblo name, but we could not understand what she told us.

PLATE 35. *Covered Woman, Marrakesh Souk, Morocco, 2002*

Many Arab women of Morocco are covered, although many have modernized, abandoning traditional garb. The woman walking here is in a djellaba covering her entire body, a *hijab* covering the hair, and a *niqab* covering the face. Many women are uncomfortable being seen, much less photographed without these traditional clothes. I had the sensation of things being hidden, of secrets being kept and guarded, of a world protected from the "other"—admittedly a difficult and strange position for me as a Westerner wanting to make portraits.

PLATE 36. *Yukie, Kiyomi, Kyoko, and Mina, in Kanazawa, Japan, 2003*

These four beauties were strolling on a Sunday afternoon under the cherry blossoms in traditional garb. Many others in the garden were also dressed in kimonos, but this group of friends stood out, and I ran to catch up with them. They posed for me against this magnificent array of cherry blossoms, which only last for a few weeks each April.

PLATE 37. *Mbere Woman, Kenya, 1980*

Creative artists are constantly moving ahead in their work, only occasionally stopping to go back and review the past—usually for a retrospective show or book. I recently discovered this image on an old proof sheet from my work in Kenya in 1980. I printed it for the first time in 2002.

PLATE 38. *Anika, Palo Alto, California, USA, 1996*

In this photograph Anika appears as if emerging from the night with a forceful wind in her hair. In fact, she was lying down on a black cloth in my living room with her hair spread to the side. I got on a high stool and pointed the camera down to get this image. When I look at it now, it is easy to conjure the night and the wind.

PLATE 39. *Schoolgirl, Ayuthaya Temple Ruins, Thailand, 2001*

It was a challenge to separate her from dozens of other school kids who were swarming around the temple ruins. There was something about her that set her apart—a resolution and sadness. On the other hand, she may have only been intimidated by my camera and would, a minute later, be running and laughing with her friends.

PLATE 40. *Woman in Wooden House on Stilts, Siem Riap, Cambodia, 2001*

All the houses here are in a flood plain and thus on stilts. The rivers were dammed in the fourth century BC by Indonesian and Indian engineers. I kept photographing as I walked closer and closer, actually climbing on to the first step of her house.

PLATE 41. *Three Berbers, Marrakesh Souk, Morocco, 2002*

These three Berbers had just entered the souk when I gestured to them and pointed at my camera. They were pleasant and cooperative as I photographed them in the chaos of the traffic of vendors, carts, and donkeys. I was so busy taking the picture that I missed my chance to ask them about their relationship to each other. In any case, I don't think they spoke any French, just the Berber language.

PLATE 42. *Mairiga and Two Wives and Children, Fulani, Nigeria, 1980*

Mairiga and his wives all dressed up for this portrait. Only a few of the children were around. Mairiga may have had other wives, I cannot remember. He is permitted by the Koran to have four.

PLATE 43. *Doña Juanita and Children, Teotitlan del Valle, Mexico, 2001*

Doña Juanita was carrying wool when I first saw her on the main street of Teotitlan del Valle, a village famous in Oaxaca state for their weavers. We were driving out of town after lunch. I asked Tony to stop the car, and Patty Preciado, our Spanish-speaking friend, approached her and asked if I could do her portrait. Because of her long silence and the way she looked at me, I was expecting a refusal. But she responded favorably to Patty in Spanish: she would be happy to pose for me but not in the street. She invited us to her house, which was adjacent from where we had parked.

Entering her very large compound where she kept giant looms for weaving, we met her children and two other women who were working. There was a large cauldron of a pink-colored liquid made from crushed local beetles. It was prepared for dyeing the wool she was carrying.

When I saw Doña Juanita's children, I knew that I wanted to photograph her with them. First, I made a portrait of her alone with the wool, the way I had first seen her in the street. Then I asked the children to join their mother under the eaves and out of the direct rays of the sun, but in good open light. They settled around her naturally in a portrait that has always seemed like a Madonna and children kind of image.

We bought a lovely pink wool scarf from Doña Juanita and mailed her pictures to her when we returned home.

PLATE 44. *Lami, Abet, Nigeria, 1980*

Lami is the wife of Adamu, who was an interpreter working for ILCA (International Livestock Center for Africa), the group in Nigeria with whom I worked. I used to spend time at her compound, *ruga*, to photograph her co-wife, Hawa, and their friends. When I did a portrait of Lami and Hawa, they dressed in identical dresses. Adamu told me that

the key to keeping both wives happy was to give to them equally. I liked both of them very much, and they teased me about staying and being a third co-wife. I wonder if they were going to consult Adamu! I have portraits of all of them, but this is my favorite.

PLATE 45. *Baker Stud, Bellagio, Italy, 1996*

This picture was taken in the very early morning behind the bakery. The sun had barely risen, and so the light was very weak. I asked Livio to hold very still and so he did, as still as the loaves of bread rising on the rack behind him. After the picture was taken, he left to go home to sleep after a long night of work.

PLATE 46. *Marrakchi Friends, Marrakesh, Morocco, 2002*

When these friends were walking toward me, only one, in the gray djellaba, had her face covered. The other woman had only her hair covered, but she promptly wrapped up entirely, covering her face, as I focused the camera. They were not as hostile as they appear . . . just independent and a bit defiant. We parted with laughter.

PLATE 47. *Visiting Home from Brooklyn for Carnival, Antigua, West Indies, 1969*

These two Antiguans were watching me as I was walking with my camera one day near St. John's. They were visiting home for carnival and then returning to Brooklyn where they worked. I thought about how, if I had been in the United States, I might have been too intimidated to stop and chat, gender such as it is, race being what it is. It was relieving to be on this island where tension was reduced and my encounter was friendly and fun. I made the portrait of these two men exactly the way they were when they were watching me. I snapped first, chatted later.

PLATE 48. *Girl with Bucket, Antigua, West Indies, 1970*

This young Antiguan girl was walking home with a bucket of water on her head. The simplicity of her arm holding the bucket formed an elegant curve against the sky. She had a nobility of movement and an aristocratic posture. You can never be sure when and where such grace will present itself.

PLATE 49. *Interns, Tea Ceremony, Ritsurin Park, Takamatsu, Shikoku, Japan, 2003*

These two young women were privileged to be selected to learn the complex rituals associated with the tea ceremony. I asked them to pose during a break from their duties at a tea ceremony being performed in a villa in the Ritsurin Park, one of the most famous gardens created by feudal lords in the Edo Period (1603–1868).

PLATE 50. *Annie and Her Dog, St. Pierre de Chartreuse, France, 1980*

When I arrived unannounced in Grenoble at my friend's house, he had gone skiing for the weekend. So I took off for a few hours in my red rented Peugeot for the mountains above the city. As I neared the top, with gorgeous views all over the valley, there was a hand-hewn wooden sign in which was carved "Pur fromage chevre, 2 km" (pure goat cheese, two kilometers), with an arrow pointing toward a small unpaved road, the opposite direction from the main village of St. Pierre de Chartreuse. Whether it was my hunger pangs or the spectacular view of the mountains, I did not hesitate to take the road less traveled. That is where I found Annie and her family. Annie, Armand, and their daughter Marie invited me to stay for Sunday lunch of goat stew, potatoes, and of course, their own goat cheese, which I also purchased before driving back to town later that day. Their small wooden chalet-style house looked out over the green mountains, some of the most beautiful countryside I have ever visited. This portrait was made just before we ate.

PLATE 51. *Musulman, Marrakesh, Morocco, 2002*

I was certain he would refuse me, as so many did in Marrakesh. On the contrary, he seemed quite pleased. I love the design in his head wrap, and the way it echoes the patterns on the mosaic in the wall behind him.

PLATE 52. *Hussein and Aisha, Berbers, Morocco, 2002*

Our car was perched on the edge of a cliff, and in order to photograph Hussein and Aisha with some light in their eyes, I too was hanging off the edge. That is the shadow of our car across the image. The sun was behind me, and I kept seeing my own shadow in the image in the viewfinder. I finally maneuvered enough to get my shadow out of the image and Hussein and Aisha in it. They were walking from the market toward their village in the Atlas Mountains.

PLATE 53. *Zapotecan Couple with Bag, Oaxaca, Mexico, 2001*

This couple was on route to the Saturday market when I stopped them and asked them to sit down on the side of the road for their portrait. I love her head wrap and his hat! The native people of the area are mostly Zapotecan and Mixtecan, mixed with some Spanish.

PLATE 54. *Monk, Angkor Wat, Cambodia, 2001*

It is always a challenge to photograph someone who is clearly in deep contemplation when you come upon him or her. This monk was in an intense dialogue with himself when we saw him sitting alone in the temple ruins. He never changed his demeanor even though he did give

me permission to photograph him. Because he was seated and so quiet, I took my time and set up the tripod. I exposed seven frames, getting closer as I worked.

PLATE 55. *Old Berber, Marrakesh Souk, Morocco, 2002*

For me, this man looks as if he has just entered the twenty-first century in a time capsule directly from the stories of the Old Testament. There were many moments in the Marrakesh souk when I felt like I was an actress in a movie reenacting stories from the Bible.

PLATE 56. *Habu, Fulani Herdsman, Nigeria, 1980*

Habu was suffering from tuberculosis. What drew me to him were his kind eyes and elegant hands. His large hat protects him from an intense sun. He also posed with his wife, but this is the best of the several images I made. His round grass house is behind him.

PLATE 57. *Ingrid, Torpo, Norway, 2002*

We saw twin churches on a hill as we were driving from Bergen to Oslo. Even though we were tired, we doubled back on a secondary road that had a sign indicating the town of Torpo. The Torpo Stave church is the oldest church in the Hallingdal Valley and has the original nave from approximately 1150. The decorative carvings date back eight hundred years.

Ingrid was the guide in this tiny one-room chapel. She seemed so gentle and spiritual, like a priestess. It was prohibited to photograph inside, so I made this portrait of Ingrid outside against the wooden church wall. Her mother is Norwegian, and her father is German.

PLATE 58. *Mr. Bun, Monk, Shirakawa-go, Japan, 2003*

We found Mr. Bun, who is a monk, in the village of Shirakawa-go Ogimachi in the mountains near Takayama. He was helping his friend organize an art exhibit by a Japanese painter who lived in their sister city, Alberobello, Italy. Mr. Bun and I walked all over the village looking for a quiet place to do his portrait. We settled on this old house in the famous Gassho style, where I felt the soft light of dusk suited the composed Mr. Bun. I took some frames of him looking down and others, like this one, with him looking up. The camera made this one the strongest. Sometimes I feel that there is a power beyond me that clicks my camera for me at a certain moment. Henri Cartier Bresson called this "the decisive moment," in which all things come together at once—something spiritual that is beyond the artist's complete control.

PLATE 59. *Rose Feiner, Palo Alto, California, USA, 2000*

Rose is my neighbor and a fascinating, intellectual woman who taught microbiology at City College in New York. She was one of the first woman PhDs from Columbia University . . . 1949. Now, she is in her late eighties, and her typical reading is Noam Chomsky and *Science* magazine. Her ancestors are Russian Jews who immigrated to New York.

PLATE 60. *The Reverend George A. Weston, Antigua, West Indies, 1970*

Known to us as George A., the reverend was a man of significant stature in the international black community. He was vice president of the Universal Negro Improvement Association (UNIA) under Marcus Garvey and a reverend in the African Episcopal Orthodox Church.

When I came to his house in Green Bay, Antigua (he was visiting his birthplace from Harlem, New York, where he then lived), we went for a stroll, and he introduced me to his neighbors. I photographed him along the way. It was uncomfortably hot in the midday sun. Returning to his little wooden house, he fixed me a cool fruit punch (that he dubbed "The Efrosina Weston special" after his first wife). As we sat down to drink, I was struck by the image you see. Looking out from his desk, with a countenance reflecting his years of struggle in a social movement to improve the status of people of color, I realized that I had not yet managed to fully commune with the reverend. I took out the camera again, set up the tripod, and exposed this image.

I can never adequately thank all the individuals who have helped me through so many years of photography—some thirty-eight of them! The work in this book dates back to when I started photographing in the 1960s and extends to the year 2003. There are many family members and friends who have encouraged me all along the way.

My parents, David and Florence Baumgarten, were supportive even when they also felt it would have been more practical for me to have been a French professor. In her last years, my mother loved to sit and look at the new portraits. Her enthusiasm was insightful and encouraging. I miss carrying my new portfolios of work for her to see.

As youngsters, my children, Anika and Julian, gracefully survived many separations when I traveled. As more mature adults, Anika helped me set a new direction in my work by being a muse and providing the persona for the Mythscape images. With his usual philosophic and analytic acumen, Julian was the only person who rigorously challenged my original title for this book, *All Our Secrets Are the Same*, pushing me to see its shortcomings and to accept a change.

As I mention in my essay, Dave Bohn and Ruth Bernhard were my brilliant teachers. Without them I might have lost my way; they provided the framework for insight and continuity. Anita Mozley collected some of my early portraits for the Stanford Museum (currently the Cantor Art Center) and curated two exhibits of my work for the museum. Barbara Millstein and Jean Claude Lemagny bought work for The Brooklyn Museum and the Bibliothèque Nationale in Paris, respectively, thus providing me with enormous encouragement. Carl Djerassi gave me a grant at a critical time so I could begin photographing in Africa. He encouraged me to keep working, something he has done for so many artists.

Frederick and Margaretta Mitchell were the enthusiastic publishers of *Antigua Black*, my first book; Paul and Bunny Mellon helped to make sure it saw the light of day. Betty Cannon hired me to photograph all of her grandchildren, the proceeds of which paid for travel expenses to photograph the sugar cane workers in Antigua. Cynthia Williams; Barbara Selvidge; my sister, Laurie Baumgarten; Pilar Manjarez; and Mark Gottlieb (whose darkroom I used for two years), all kept rooting from the sidelines, always interested to see new work. Helen Bing loves my portraits of kids and bought many for the Stanford Children's Hospital. Grant Barnes, director of the Stanford University Press in 1987, embraced my idea of a publication of vintage photographs to celebrate Stanford's centennial, resulting in *The Stanford Album*. Warner Roberts matted and framed two exhibits for me in exchange for the photographs he loved.

And the angels continue right up to the present. Peter and Juthica Stangl connected me with Joska and Gabi Bubics, who drove me for many days to

ACKNOWLEDGMENTS

farms in the Hungarian countryside. Patty Preciado was our friend and guide in Oaxaca. Jill Friedman, dear friend in Bellagio, Italy gave me her house for several weeks, and introduced me to all the bakeries in Bellagio. Norris Pope, my editor at Stanford University Press, has been my devoted fan and tireless supporter through the various iterations of this project. Through all these years my good friends Marilyn Yalom and Stina Katchadourian have counseled me during times of doubt and edited various manuscripts.

Recently, Paul Sack, Joel Leivick, and Norris Pope helped me to select the final images for this collection. I could not have had a better team for this process. Terry Gannon has so generously provided me with help at the computer and burned many CDs of my work for galleries and museums. Pamela Jones and Connie Henry Walley, friends from high school with whom I have reconnected during the era of email, have been willing, skillful editors. We appreciate especially our Thomas School training, which prepared us well for our discussions about word usage or the potential obscurity of such terms as *phenotype* or *eidetic*. Mary Brown Lawrence has been a terrific mainstay through these many years, ever since we worked together on *The Stanford Album* in the 1980s. She keeps me laughing through it all. More recently, Heather Snider has been an invaluable advisor and assistant in matters regarding the book and exhibitions.

In 2000, as I was gearing up to finish this project, I met Kay Craven in one of my UC Santa Cruz photo workshops. Kay and her husband, Bill, were building a darkroom in their house. I mentioned offhandedly that I was without a work space, and Kay proposed the idea of sharing her new facilities in exchange for some private tutoring. Our mutual interests have contributed to a fine partnership for three years, and we look forward to many more. Without Kay, I might still have been "darkroomless," which is akin to homelessness for the likes of me. Thank you, Kay and Bill.

I am also grateful for the commissions and grants I received from the following institutions:

ILCA (International Livestock Center for Africa)
Syntex Corporation
Djerassi Foundation
Il Fornaio Corporation
Center for International Studies, Stanford University
The Distribution Fund
California Arts Council

In addition, I would like to acknowledge the following galleries and museums that will be exhibiting the photographs included in this book during 2004–2005:

Stanford Art Gallery
Stanford University, Stanford, California, USA

Scott Nichols Gallery
San Francisco, California, USA

The Photographer's Gallery
London, England

Throckmorton Fine Art
New York, New York, USA

Monterey Museum
Monterey, California, USA

Finally and most importantly, without my husband, Tony Browne, this work would not have been completed. For his encouragement, support, persistence, and above all, willingness to take on the role of sherpa for the last three years, I am forever grateful. We had so much more fun working in these locations than vacationing there.

One thousand two hundred fifty copies of *Under One Sky*
were printed by Dualgraphics, Brea, California

Printed in the Fultone® process on 100# Vintage gloss book

Bound by Roswell, Phoenix, Arizona

Designed by Janet Wood

Typeset by James P. Brommer in
12.5/16 Centaur and Trajan display